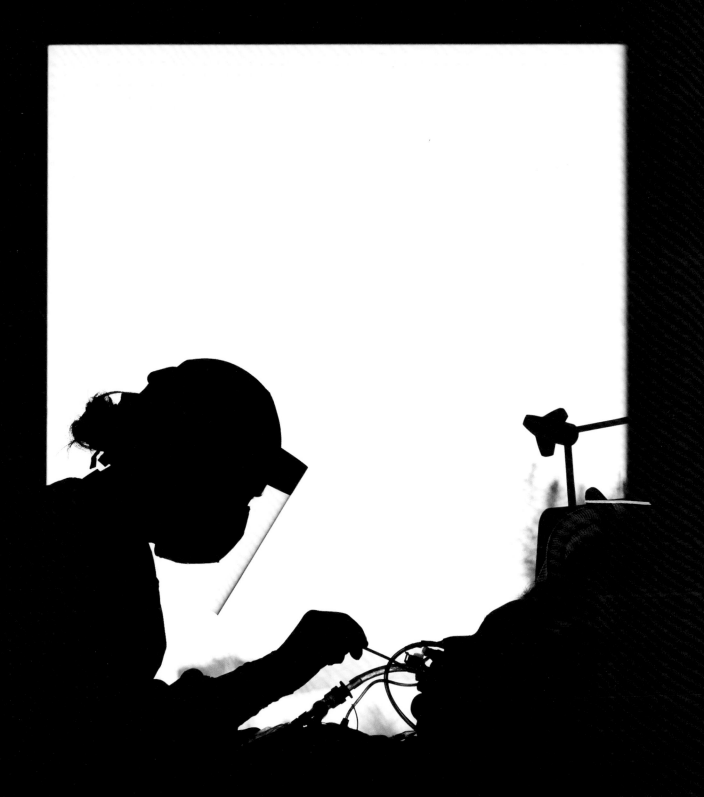

(previous page) Critical-care nurse Rianne Pater cares for her patient.

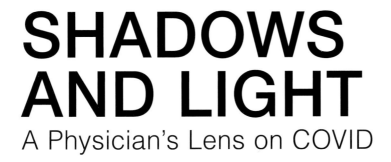

SHADOWS
AND LIGHT
A Physician's Lens on COVID

HEATHER PATTERSON, MD

GOOSE LANE EDITIONS

Edited by Valerie Mansour.
Cover and page design by Julie Scriver.
Photographs by Heather Patterson unless otherwise indicated.
Printed in Canada by Friesens.
10 9 8 7 6 5 4 3 2 1

Goose Lane Editions acknowledges the generous support of the Government of Canada, the Canada Council for the Arts, and the Government of New Brunswick.

Library and Archives Canada Cataloguing in Publication

Title: Shadows and light : a physician's lens on COVID / Heather Patterson, MD
Names: Patterson, Heather (Emergency physician), author, photographer.
Identifiers: Canadiana 20220194424 | ISBN 9781773102740 (hardcover)
Subjects: LCSH: Medical personnel—Alberta—Calgary. | LCSH: Medical personnel—Alberta—Calgary—Pictorial works. | LCSH: COVID-19 (Disease)—Patients—Alberta—Calgary. | LCSH: COVID-19 (Disease)—Patients—Alberta—Calgary—Pictorial works. | LCSH: COVID-19 Pandemic, 2020-—Alberta—Calgary.
Classification: LCC RA644.C67 P38 2022 | DDC 362.1962/414009712338—dc23

Goose Lane Editions is located on the unceded territory of the Wəlastəkwiyik whose ancestors along with the Mi'kmaq and Peskotomuhkati Nations signed Peace and Friendship Treaties with the British Crown in the 1700s.

Goose Lane Editions
500 Beaverbrook Court, Suite 330
Fredericton, New Brunswick
CANADA E3B 5X4
gooselane.com

For all of us who are living through the pandemic.
May we find light within the shadows.

And to Kip, Quinn, and Hannah, for helping me find mine.

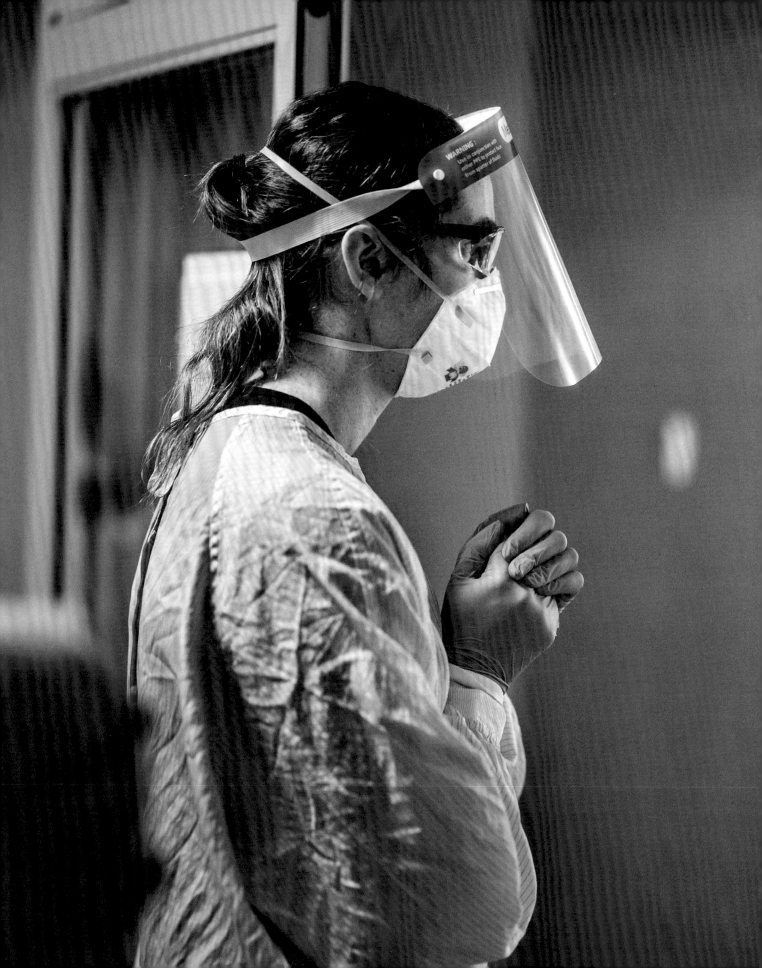

FOREWORD

COVID-19 has reshaped our world. How we see ourselves and each other. The way we view our governments and our neighbours. Nowhere has the impact been more profound than within the health-care system.

Inside the walls of our hospitals, providers have been pushed beyond their limits again and again. Relentlessly pursuing life itself on behalf of patients. Behind each decision, procedure, tube, mask, or medication was, and continues to be, a person desperately clinging to life. And behind the patients are the people who love them—often unable to be by their side and only able to whisper their words of love and hope over a screen. This collective experience has, at its very core, become about who we are as people.

In *Shadows and Light*, Heather Patterson weaves together text and image to take us directly to the front lines of the pandemic and the world of health-care workers. Their stories are life lessons that can help us, giving us the will and resilience to persevere. Moreover, Heather generously shares her own story through these pages—from the lows of burnout to finding the beauty and meaning in her work. This glimpse into her own experience reminds us of the power of vulnerability and restores our sense of humanity at work.

I had the privilege to work with Heather when she was a resident doctor during my time as a pediatric emergency physician in Calgary. Smart, keen, and compassionate, she embodies the values of what it means to be a physician.

Heather's book is a portrait of experiences shared by health workers across the world. She leaves us with hope. In pain, there can be beauty. In sickness, there can be healing. In crisis, there can be humanity.

Dr. Katharine Smart
CMA president 2021–2022

(opposite) Critical-care nurse Kathryn Ursel steps outside an ICU room while an X-ray is taken. She has already spent two hours and forty-five minutes providing care in full PPE.

Trauma Bay 1, Foothills Medical Centre Emergency Department. Calm before the storm.

INTRODUCTION

It was the night I lost a patient who I thought would survive and shared a terminal diagnosis with a man not much older than myself. I hadn't stopped to eat, drink, or use the bathroom in over eight hours, and by the end I was exhausted. It was a difficult night but not unusual except for one thing: I felt nothing. I struggled to rally the passion I had once felt as an emergency physician. I wondered how long I could continue.

As a physician, I have met people from all walks of life and heard stories I would never have heard otherwise. I have saved lives, laughed with children, sutured lacerations, cut open chests, and treated heart attacks. I feel privileged to have been present for all these moments in my patients' lives, but this privilege comes at a cost. Emergency physicians experience up to three times more burnout than other specialties, leading to shorter career length. And at forty-one, I was approaching my tenth year.

Years before, I had begun my journey as a blissfully enthusiastic resident, entering my specialty training after medical school, inspired by my colleagues and my patients. I became enamoured with making diagnoses, connecting with each patient's story, and being part of the emergency team. I loved the pace and the thrill of what sadly is often a patient's worst day. With my parents and sister living in another province, and not yet having started my own family, I immersed myself wholeheartedly. Never did I imagine a time when emergency medicine would feel more like work than a calling.

I remember my second shift of solo practice after five years of residency, a night shift. I was the first to arrive in the trauma room as a seven-year-old girl was carried in in the arms of the triage nurse. She was critically ill with myocarditis, an inflammatory heart condition. The room was dark. Quiet. But soon the silence was punctured by the wailing of heart monitor alarms and the voices of

the team rushing into the room to save her life. Unflinching, we drilled a rigid metal needle, called an interosseous line, into her tibia to deliver medications. We intubated her. CPR. Defibrillation. Epinephrine. Glucose. Calcium. Repeat defibrillation. I was in my medical element. I had just written my exam and knew what to do. I was focused on leading the resuscitation with the emotional detachment that is critical for a physician to have clarity of thought and make difficult decisions. But I had not yet learned how to take time later to acknowledge and manage the emotions I so adeptly tucked away.

I can still see her two front teeth, uneven as they were growing in, and I can still hear her dad sobbing, desperately pushing us to restart CPR even after she had died, pleading with us to continue. Outside was a waiting room full of the injured and ill. Suppressing my emotional reaction to this terrible loss, I quickly moved on to the next patient.

This heartbreaking event accelerated the hardening process of practising medicine. I felt that—especially as a woman in medicine—I should not and could not have an emotional response, let alone display or discuss my feelings. Besides, with a child at home now and another on the way, there was no time.

My first month as a staff physician presented many more chances to reinforce this detachment "skill set." In the midst of less emotional cases, including broken bones, infections, and abdominal pain, I pried open a man's chest and held his damaged, unmoving heart in my hands, before telling his wife and two young children that he had died. I intubated a man with a deadly intracranial hemorrhage, watched him die before me, and sat with his family, who, in their grief, felt it was their fault for ignoring the warning signs. I flew with STARS air ambulance, where a young man bled to death on our stretcher from traumatic internal injuries despite all we tried to do.

Over time, I would develop a reputation for having a "black cloud"—what we say when someone is regularly involved with caring for critically ill patients. It is considered a badge of honour, but it isn't normal. I wasn't normal by that time, but none of us were. And those of us who thought we were—we were lying to ourselves.

Increasingly, I became aware that not only the work itself but the culture of medicine can be difficult—with criticism of one's diagnostic and treatment decisions, comparison to others, and demands for perfection. This can breed imposter syndrome, the feeling that you aren't good enough, coupled with the worry that one day someone will find you out. I would persist at work, making sure my

handover was perfect even if I was two hours late leaving a shift. I would doubt my own decisions and lie in bed thinking about cases. I'd say yes to nearly every request for volunteer work. I wasn't sure if the expectations I was trying to meet were my colleagues' or my own—but I was sure they were exhausting.

After almost a decade, the impact of continual exposure to some of life's toughest moments, coupled with high-stakes decision-making, caught up with me. I was left with an unfortunately common problem—emotional exhaustion and cynicism. Burnout. Recent data has suggested that nearly fifty per cent of American physicians, thirty per cent of Canadian physicians, and between sixty and eighty-six per cent of emergency physicians suffer from burnout. And that was *before* the pandemic.

When I arrived at work a feeling of "meh" would take over. I silently carried on, sharing this only with my husband, Kip, also an emergency physician. I was determined not to quit medicine—something I had dedicated more than half of my life to. Even if I couldn't feel it at that moment, I knew I loved my career, the team I worked with, and the humbling experience of learning something new about medicine or people every day.

Kip and I brainstormed about how I could get back to my "normal," regain my passion for medicine, and stop the burnout from spilling over into my personal life. Close friends and family, now aware of my secret failure, offered advice. How about a long vacation, more outdoor adventures, playing piano, or book clubs with wine? Counselling, regular meditation, or a new exercise plan?

One night, as we sat in bed strategizing, Kip suggested something that wouldn't be an escape but could shift my perspective—photography. Intrigued, I sat up from my pillow mountain. A wellness-based project, in the emergency department, using an artistic medium that I love. To remind me, and maybe others, about why we keep doing this work. Being a pessimist, I laughed, picturing the rejection letter from the hospital administration. My husband, the optimist, told me to sleep on it. The next day I began my proposal. It was late January 2020 and COVID-19 had not yet arrived in Alberta.

For over twenty years, photography has offered me a calm space to slow down, find perspective, and observe the details of life. It started with a film camera that I carried everywhere, shooting the beautiful scenery of Ontario, my home province. My first photo was published in *Cottage Life* magazine in 2002—an old stump surrounded by fall colours and a sunset, its decaying trunk supporting new life. My first digital camera—a wedding gift from my parents—shaped a new approach

to photography. Without the constraints of film, I took thousands of photos of my children, smiling angelically. But in time I became determined to capture real life —not just the angelic parts—to remember how those days *felt*.

I find joy in capturing our family and the moments that will sustain my memories. It's the images of crumbs under the table, temper tantrums, and my husband desperately trying to nap while a toddler jumps on the bed that truly resonate with me as a photographer. Making photos in the emergency department seemed like a natural progression. Like my family life, it is real and messy, busy and chaotic, and filled with emotion.

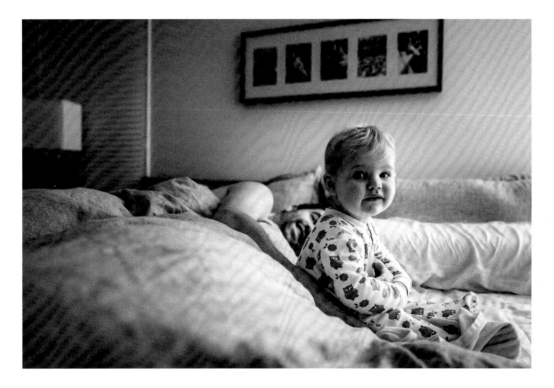

The early years. Despite being awake for twenty-six hours on-call during residency, Kip couldn't resist a snuggle with little Hannah before turning out the lights. Then we would close the door, tiptoe to the basement, and play as quietly as we could until he woke up.

I vacuumed last week — I think.

Even after a decade of reminding the kids that Dad or Mom is sleeping, it can be hard to stifle the laughter. Sometimes I can't resist capturing a quick photo before rushing them to the basement or outside where they can be as rambunctious as they wish.

Kip and I alternate working in the emergency department and being home. We need to be fully interchangeable to respond to homework challenges, social dilemmas, and household chores. Some days we've actually met in a parking lot halfway between our departments to exchange our precious cargo, have an update, a quick hug, and an "I love you."

Time together as a family is precious and, during the busier months of work, too infrequent. To quickly transition from work to home life, Kip and I often talk about our shifts through the glass door of the shower. Then we head downstairs to hear about the kids' days. We're aware of the brevity of this season of life and try to find ways to make memories and lasting traditions.

In developing my proposal, I worked with Alberta Health Services (AHS) to diligently address the challenges involved in photographing in the hospital and moving from the role of physician, with the core value of patient privacy, to the role of photographer, sharing images and stories of those who would otherwise remain anonymous. Ethics reviews, meetings with the privacy and legal departments, and correspondence with communications teams and AHS leadership were encouraging, incredibly helpful, and supportive.

Kip wasn't surprised. Me—I was still waiting for that denial letter.

COVID's arrival in Calgary was simultaneous to the development of this project. At the request of AHS, I agreed to expand the scope—shooting not only in the emergency departments but providing a more comprehensive picture of our pandemic response. I realized that this could act as a historic record to show how the pandemic was affecting front-line workers and citizens and generate empathy. Eight months after our first conversation, I received approval to photograph at five Calgary hospitals: Foothills Medical Centre, Rockyview General Hospital, Peter Lougheed Centre, South Health Campus, and Alberta Children's Hospital. The photographs in this book come from all five of these hospitals.

The integrity of this project remains of utmost importance to me. My guiding principle was to put people first—to ensure that participants were well informed and felt safe and respected. Patients under my own care would not be photographed. I would never make a photo without consent. I committed to putting my camera down if a patient or staff member needed me. My priorities were to provide comfort, respect private moments, and be helpful. An image of a healthcare worker holding a patient's hand would be meaningful only if I was willing to hold that hand, not just photograph it.

In November 2020, during Calgary's second COVID wave, I walked into the Foothills Emergency Department with my camera instead of my stethoscope.

To get prepared, I'd taken courses and been mentored by university professors and internationally recognized photographers. Still, I was terrified. But the emergency department was a safe environment for me. Surrounded by supportive friends and colleagues, I had time to understand and respond to the physical and technical challenges—harsh artificial light; photographing in personal protective equipment (PPE) through the layers of my face shield and goggles; the faces of the

team obscured by the reflective surfaces of their own shields and goggles, with deep shadows hiding their eyes; and finding room to photograph unobtrusively in a crowded, busy space.

Day by day I became more comfortable, but nothing could have prepared me for the impact of photographing my friends and colleagues and their patients. I could see more clearly the role of each team member and the warmth and empathy they exhibited. Two months later, because the emergency department was well staffed, I was granted a twelve-week clinical sabbatical. I could focus exclusively on my photography and expand my project to other areas of this hospital and to the other four.

Early in the project, I realized that my photographs could be a gift to colleagues. A good friend's father had recently retired after dedicating his entire career to a family medicine practice. He did not have a single image to represent his work, his patients, or his community. I now had a repository of images for staff to share with their family and friends, portraying their work life.

I never intended to write a book. I'm well educated in the language of medicine, science, math, and music. Point-form notes, equations of gas exchange, diagrams of body parts, and lists of investigations are my language. My only university English class was the hardest of my degree. My roommate, Carrie Fish, now a teacher-librarian and literacy specialist, looked with concern at my first five-hundred-word essay. With her red pen forming *X*'s with unparalleled speed, she cancelled a host of misplaced commas, taught me how to use *however* correctly, then laughed and asked what on earth I was trying to say. I passed English due to her help—neither of us suspecting that this poor pre-med student would someday become an author.

The seeds were planted when my photography mentor, Deb Schwedhelm, a fine art photographer, insisted that I journal about my new experiences. I learned that while photography allowed me to see, writing allowed me to understand. This rare opportunity to slow down, make meaningful connection with colleagues, patients, and families, and recognize and process difficult emotions gave me the change of perspective I needed. It seems ironic that this project coincided with the arrival of a global pandemic—one of the most challenging times in our lifetime for health-care providers—while also allowing me to regain my sense of self. I have witnessed more tragedy and suffering than ever, but I have also experienced more joy.

Woven together with the stories of front-line workers, patients, and families, is my own story, brutally honest and often uncomfortable to share. I am inspired by

the people in these images who have given us a window into their COVID experience, often by allowing themselves to be vulnerable and exposed during their most difficult moments. And I realize the need to follow their example.

Medical culture carries a long tradition of telling ourselves and others that we are "fine," but perhaps the pandemic offers us the chance to accelerate a much-needed change. I hope health-care workers and others in our community see glimpses of themselves in these images and stories, take time to reflect, and become curious about others' experiences. It is time for us all to engage in discussion about how we can promote self-compassion and empathy within our culture and our communities. We owe it to the people we love, to the people we care for, and to ourselves.

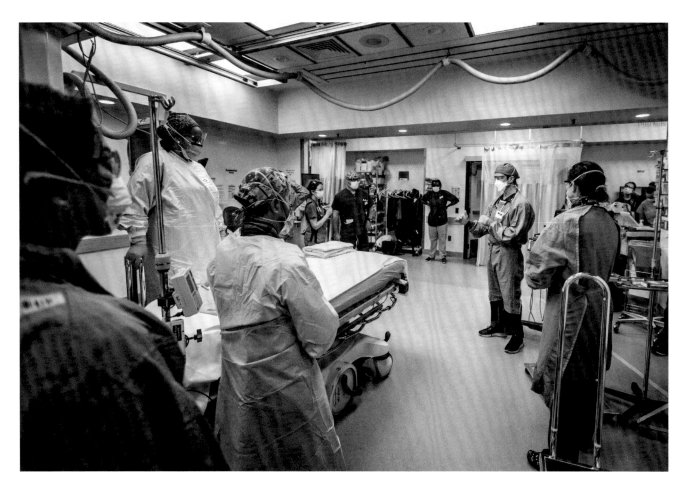

Dr. Rick Morris, an emergency physician, preps the team: the patient's condition, roles and responsibilities, and medical management. A solid plan and understanding helps the team function at its highest level and provide the best care.

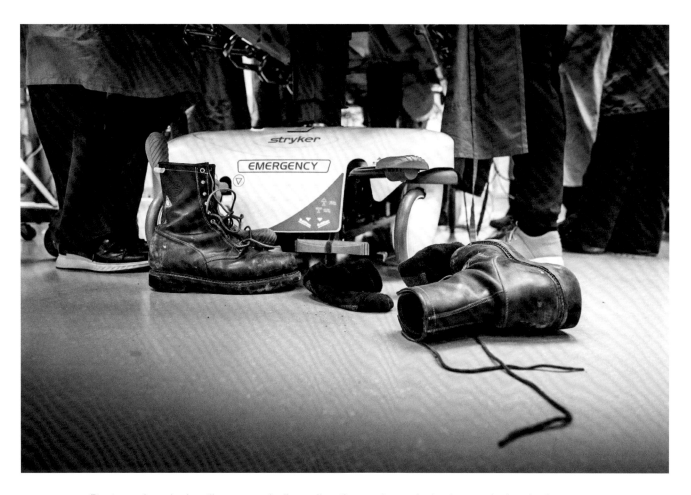

Boots and socks hastily removed, discarding the markers of who he was before he lay on our stretcher.

(right) CPR in progress while Dr. Matt Erskine reviews a critical blood test result and looks for causes of cardiac arrest. The patient's condition deteriorated a few minutes after arriving in the emergency department.

(overleaf) An uncommon success — his heart beats again. We call this the return of spontaneous circulation. Dr. Morris calls the interventional cardiologist to arrange for an immediate angiogram to look for blockages in the heart's blood vessels. The cardiology technologist, Rao Shafiq, repeats the electrocardiogram (EKG) to look for evidence of a heart attack while the team delivers medications and prepares to move the patient to the cardiac catheterization lab.

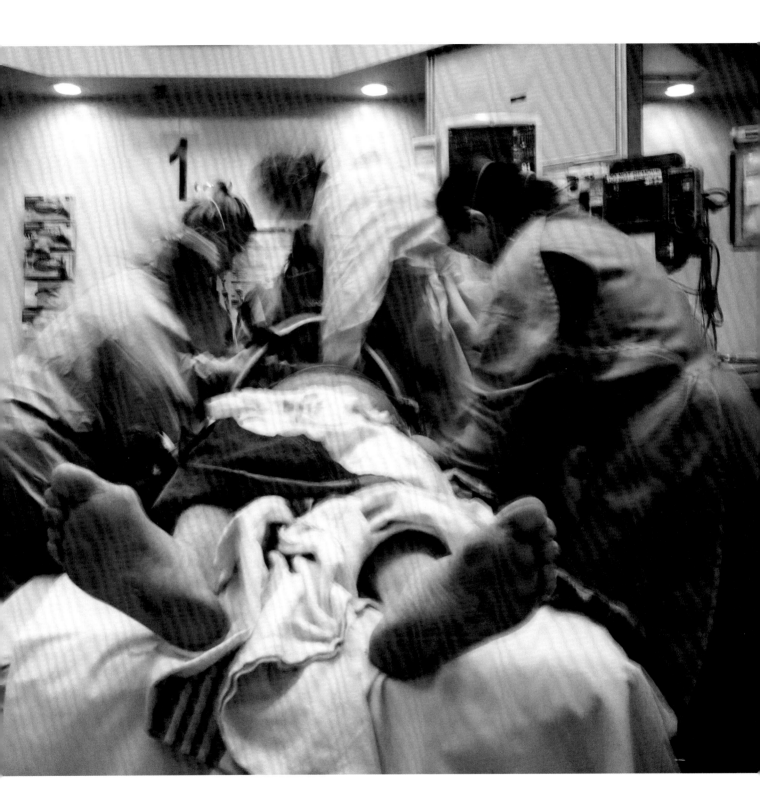

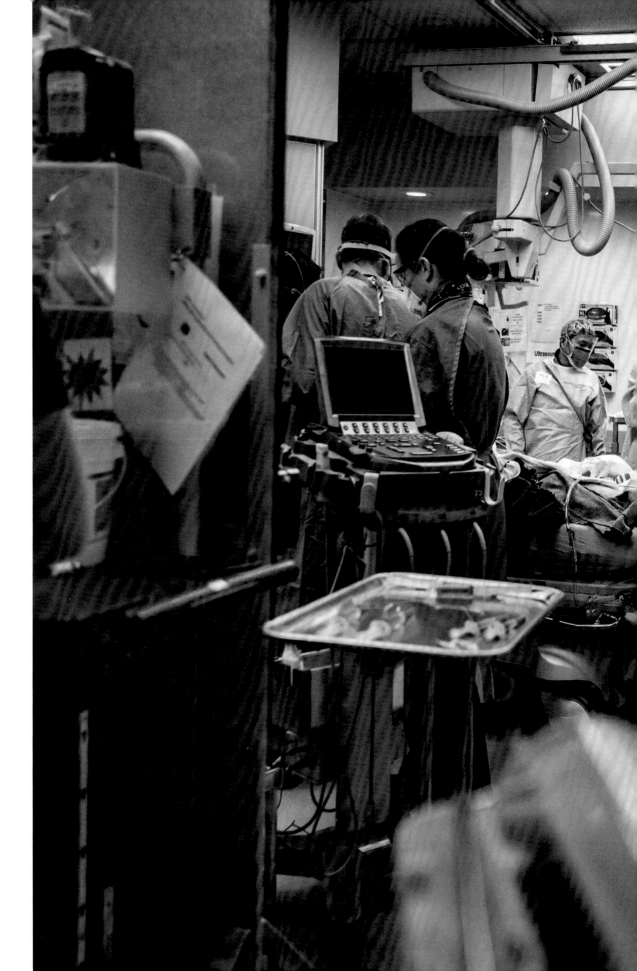

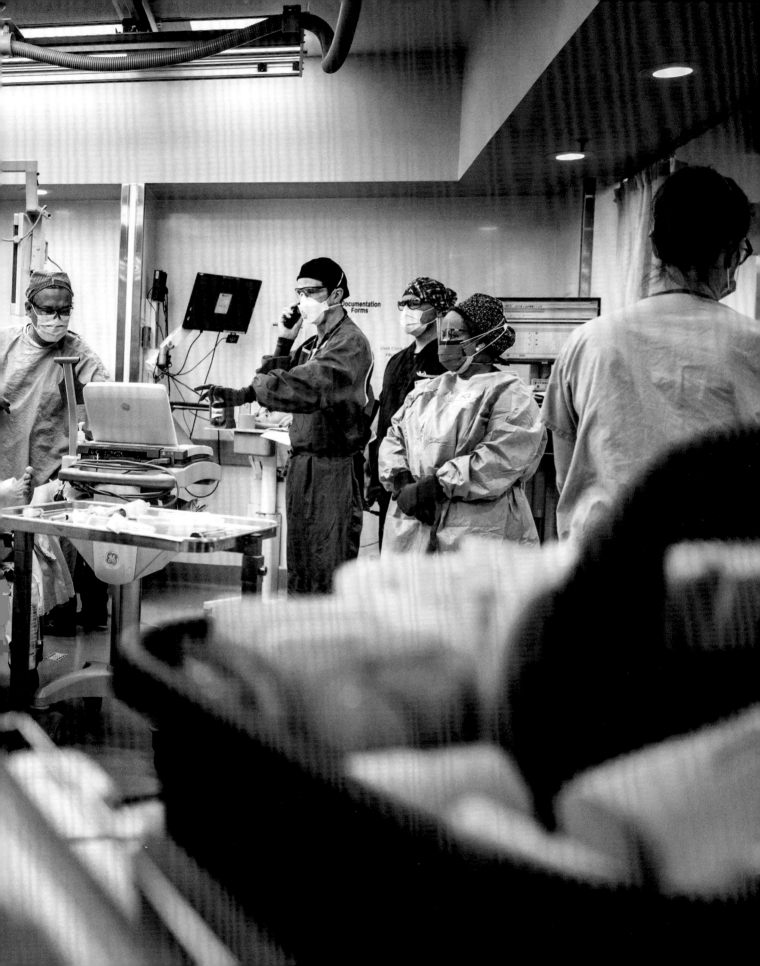

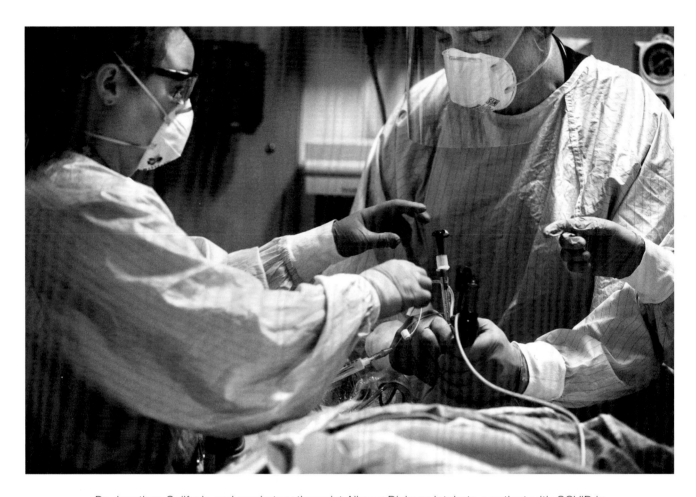

Dr. Jonathan Guilfoyle and respiratory therapist Allyson Dickson intubate a patient with COVID in the emergency department. In February 2020, news of a mysterious virus and whispers of a global crisis had already unleashed a torrent of fear and uncertainty. The media was flooded with stories of health-care workers in other countries working without PPE, systems overwhelmed, and people dying. I was devastated for my international colleagues and their patients. I had to turn the news off — it was giving me COVID insomnia. As emergency physicians, we know what to do when a diagnosis is uncertain, but never before had I worried about my own safety or the availability of resources like PPE, ventilators, and hospital beds.

ONE
The First and Second Waves
Mourning What Was Lost

"The first intubation of a known COVID-positive patient felt so different than any others I have done because I had never thought of my own safety before. I felt personally vulnerable."

—Dr. Hannah Park, emergency physician

"Wuhan." It was the only thing I heard Kyle Cridland, charge nurse in the emergency department, say. I was sitting at the desk beside another physician and a few nurses, writing a patient's exam findings on a chart. We all stopped. I could feel my heart pound. "Where would you like to see him? He's in exam room one. He's come right from the airport." Pause. "Where are the Ebola suits?" were the only words I could muster. While we were working so hard to learn about this virus, I don't think we felt ready for its arrival on our doorstep.

I had read all the emails, but suddenly I couldn't remember the details. Where should I see the patient? Was it even safe to examine him? What PPE did I need? Was my patient afraid? Was his condition unstable? I took a moment to gather my thoughts, calm my heart rate, and page my department head. While I waited, I called my husband:

"It is here."

We saw the first confirmed case of COVID in Alberta on March 5, 2020, and the World Health Organization proclaimed it a global pandemic just six days later. Alberta declared a state of emergency and instituted the first of many restrictions. These milestones felt artificial. The pandemic, for me, had already started when cases were confirmed in North America and when I began worrying about how our family would manage.

PPE was a source of stress and uncertainty; I saw it as the single critical barrier for my safety. While our leadership worked tirelessly to acquire PPE and maintain the supply, I heard stories of physicians using bandanas to cover their faces. If I was forced to choose between a risk to my own safety and the life of my patient, I knew I would choose to save my patient. And so, I joined a group of specialists from across Alberta. We purchased a backup supply of reusable masks and shields for the health-care teams who would be involved in intubation. It was a controversial move, perhaps seen as a lack of faith in our leaders. But it provided the needed reassurance that we could care for our patients *and* protect ourselves and our families from COVID.

During the first wave we had enough doctors and nurses to work efficiently, because everyone wanted to do their part in fighting the pandemic, despite the risk to personal safety. My job was surprisingly satisfying as the medicine was interesting and the team worked well together. With so many places closed and social restrictions instituted, my only social interactions outside of immediate family were at work. We took time to check in with one another, to pause and connect. Above their masks, I noticed the colour of my colleagues' eyes and the way their eyebrows showed their smiles or frustration. They began to feel more like family, and there was strength in facing this beast together.

Dr. Kip Rodgers, my husband, an emergency physician on the front lines, observes his patient. Kip's tense posture reflects the emotional toll, apparent even in the early days of the pandemic. He and I struggled to come to terms with our new reality. We revised our wills and shared our computer passwords. We lay in bed at night, tossing and turning, wondering how to reduce the risk to our children, aged seven and eleven, our parents, and other family. Kip shaved his beloved mountain-man beard to don his N95 mask. We taught our kids not to hug us when we got home from work. And we sprinted naked through the living room to our designated decontamination shower.

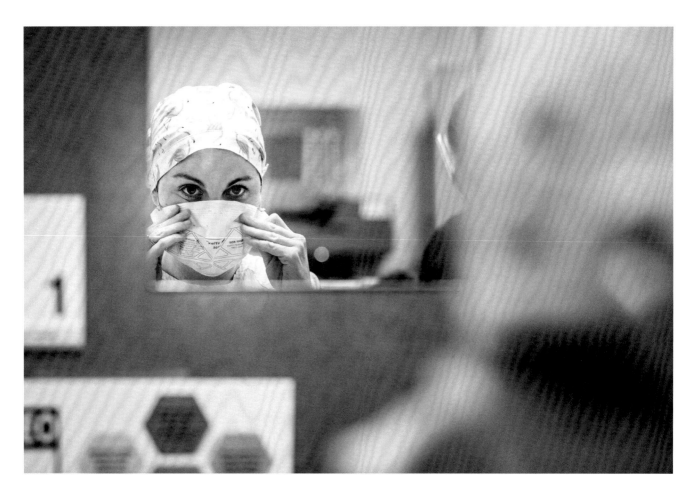

Melissa Vines, a critical-care nurse clinician, dons her N95 mask and ensures a proper seal to protect herself during an intubation. Next, she will add goggles, face shield, gown, and gloves. Intubation is an aerosol-generating medical procedure, so this level of vigilance is needed. Donning and doffing PPE disrupted the usual flow and reduced our ability to move quickly between patients. We tried to ignore the heat and sweat collecting under the layers of PPE and to see the person in front of us through the fog on our goggles — in hope that they could see us too.

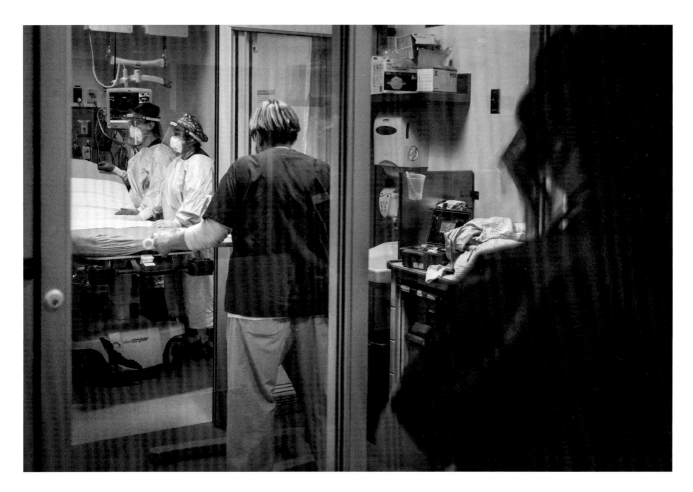

When treating a critically unwell patient with COVID, the emergency team is divided by glass doors into inner, middle, and outer layers — a difficult consequence of having small isolation rooms and trying to protect staff and other patients from exposure. How would our team continue to function, separated by glass? Would patients feel an unintended barrier — between us and them — as we created a barrier between us and COVID? And what about the absence of family at the bedside to provide comfort — and critical information to staff? Would our patients be afraid and lonely? Would some of them be confused or delirious? These questions lingered and rolled around in my consciousness. I mourned for how it used to be.

Doctors, nurses, respiratory therapists, health-care aides, trauma specialists, and paramedics work together to care for a patient in Trauma Bay 1. Despite the many challenges, the early pandemic encapsulated what an emergency physician experiences — the thrill of the moment, working with your team; the intense focus of a resuscitation; the satisfaction of saving a life, or the sadness when a life ends too soon; the privilege of being trusted; and the exhaustion of perpetual decision-making and shift work.

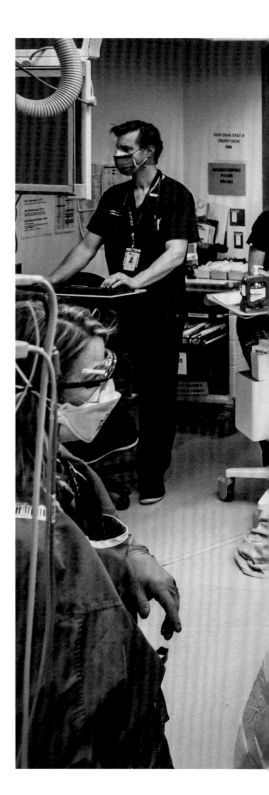

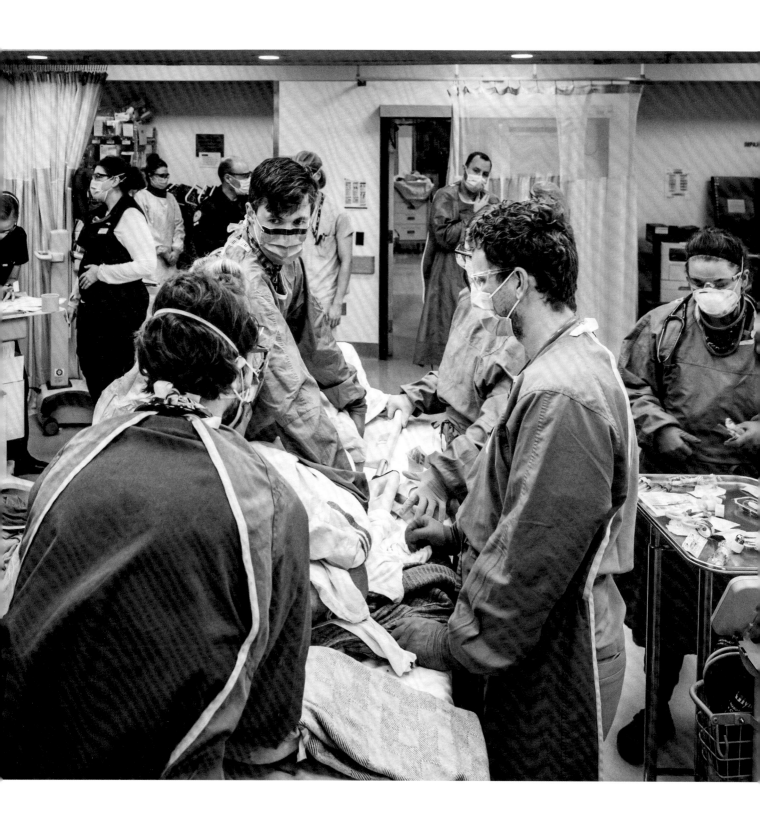

At the end of the first wave, Kip said, "See, that wasn't too bad." And I had to agree. It was stressful, but not compared to the stress in hard-hit places like New York. We didn't run out of PPE, and our system had not been overwhelmed.

Then, after a few months of fluctuating but mostly low case numbers in Canada, there was news of a devastating second wave in other countries, foreshadowing the loss of life that was to come. By November 2020, the second wave of COVID had arrived in Calgary. It felt like a replay of the first, but much worse, with more patients admitted to hospital and many dying in the ICU. By this point, I had begun photographing on my days off and would soon begin to share some of my photos on Instagram. I desperately hoped that my images of the team's hard work and resilience would encourage people and help them keep going as COVID took over our city.

The second wave was our first experience of COVID patient numbers exceeding normal hospital and staffing capacity. COVID wards were established and intensive care unit (ICU) rooms often hosted more than one patient. Teams of clinical staff were redeployed from other specialty areas to help. It was staggering—the sheer number of people admitted to hospital, how unwell they were, and the number of staff required to provide their care.

While patients with COVID overwhelmed many clinical areas, the emergency department remained busy but fully staffed. As a result, in addition to their usual clinical duties, many emergency physicians were able to act as "surge physicians" in harder-hit parts of the hospital. It was at this point, after six weeks photographing exclusively in the emergency department, that I started a twelve-week clinical sabbatical to focus on my photography.

I began to broaden my scope, dig deeper, and photograph what was happening in other clinical areas. Day-to-day work in the ICUs and COVID wards was different than in the emergency department. But by making photos, I saw many similarities—the need to integrate evolving knowledge into treatment and management, concern for staff and patient safety, team communication through the barrier of glass, and the absence of families.

My colleagues welcomed me in my new role. "You may not see what happens when you arrive with your camera," said friend and colleague Dr. Kasia Lenz. "But the morale and mood of the department is more positive. People are excited. They feel recognized and appreciated."

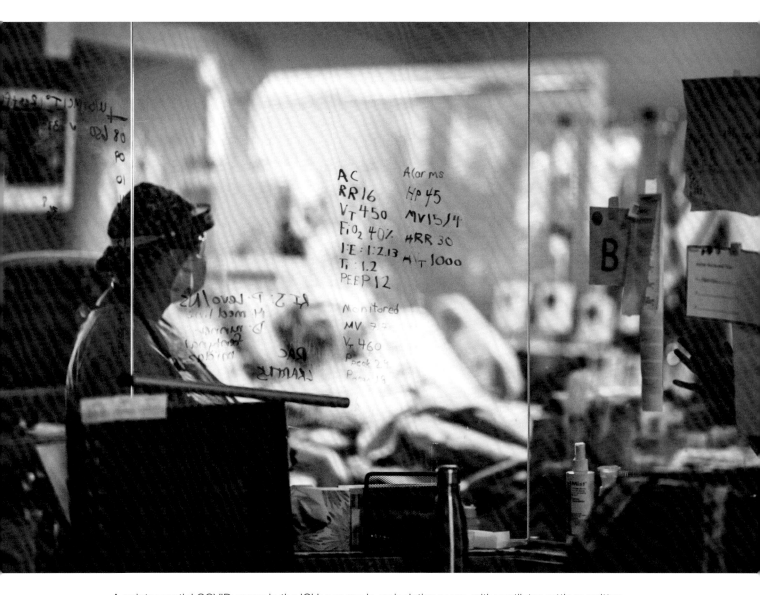

A quintessential COVID scene in the ICU: a nurse in an isolation room, with ventilator settings written backwards from the inside of the window to share critical information with team members on the outside.

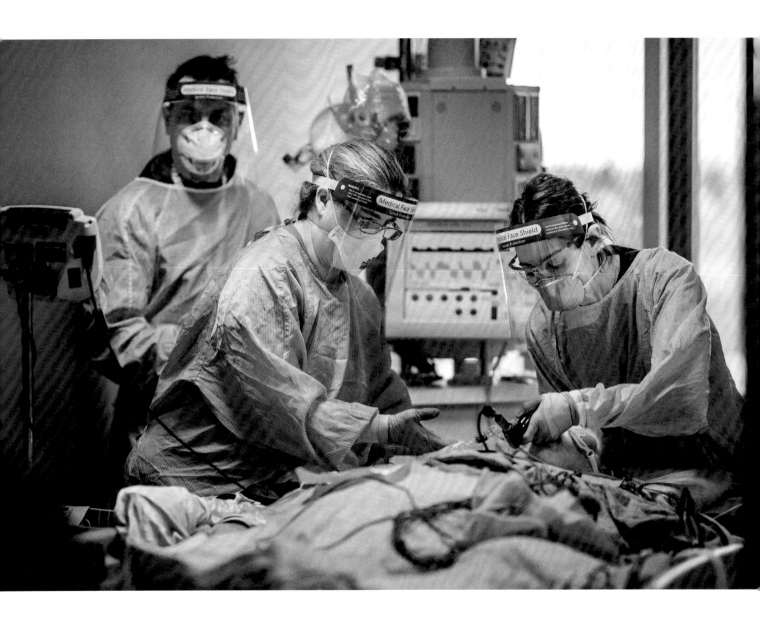

In addition to photographing health-care workers, I was now making photos of patients affected by COVID. This shift put faces on the statistics. Patients and family members began to tell me their stories and talk about their struggles. Their willingness to share had a profound effect on me. I started to be more open too, to embrace the differences between being a physician and a photographer. Understanding who these patients were, knowing details about their families, and their lives—this personalized the pandemic even further.

Our growing understanding of COVID led to shifting visitor policies. Hospital leadership had to make difficult decisions. While committed to keeping patients and staff safe, they also understood the impact on everyone. During this wave, only a patient who was non-infectious (fourteen days or more after infection) or facing imminent death could be visited by family or a designated support person. Otherwise, patients dropped off at the emergency department or brought in by ambulance were whisked away to be treated, leaving family to wait at home for phone calls and updates from staff. Words of love—and even what might turn out to be goodbyes—were whispered over the phone before intubation, while staff, instead of loved ones, held the patient's hand. I still struggle with the frustration and sorrow of knowing I could be present at the bedside while families often could not. And when families were present in the hospital at the end of life, the goodbyes were hard to witness, and I put my camera down out of respect.

(opposite, left to right): Dr. Jeff Odenbach, a critical-care fellow; Debra James, a redeployed respiratory therapist; and Dr. Cathy Dorrington, a redeployed emergency physician, intubate a patient in the ICU. After watching COVID overwhelm hospitals in other countries, Dr. Dorrington knew she needed to volunteer as an ICU surge physician. She spoke of "saving lives" early in the second wave, when "the time felt hopeful and busy, and brought some sense of control over this disease," adding that "some patients would even recover in a short period of time and be extubated." But later in the wave, her tone had changed. "The emotional experience was more of sadness." ICU volumes had dropped, partly due to recoveries, she said. "But it also meant that many patients I had admitted and cared for in earlier weeks had died. Those who remained in the ICU were those in whom complications of COVID infection continued to ravage, and the hope of survival without significant disability, or survival at all, decreased by the day."

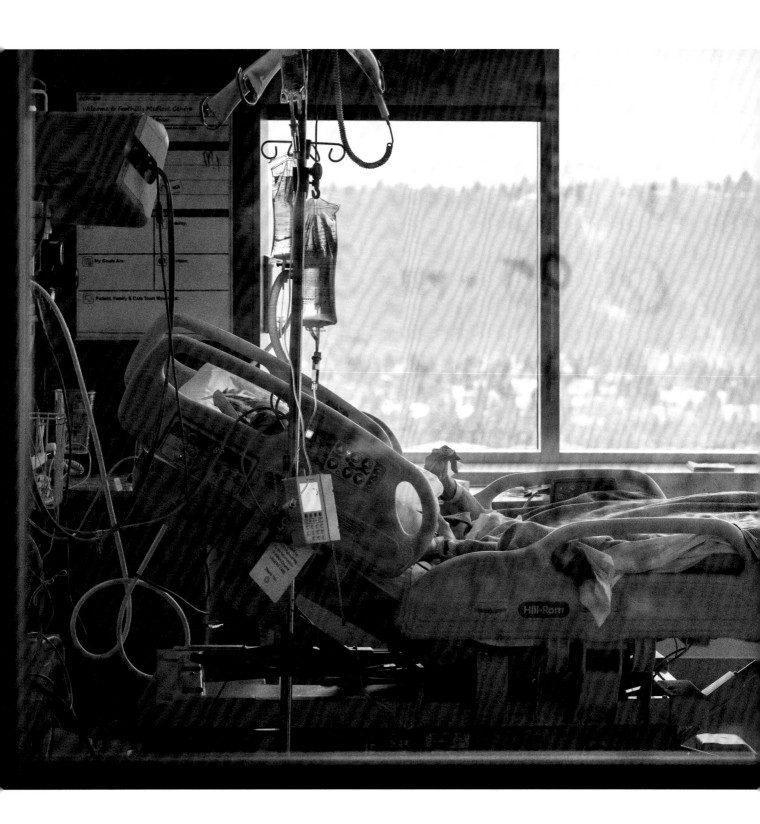

Behind sealed glass doors locking her and her COVID in — and others out — an elderly woman lies in the most beautiful room on the ward. This corner room looks out at the Bow Valley, where snow blankets the hills and distant mountains mark the edge of the sky. I wondered if she could see them, if she longed to be out in the sunshine, or if she was simply struggling to breathe. I saw her reach up to adjust her oxygen mask, to wipe her face with a tissue. Her age was spelled out by her slow movements and her tiny frame, which barely made wrinkles in the faded pink hospital blanket. I imagined my grandmother's face behind the mask. The chair in the corner of the room was empty; family was waiting and worrying at home, wishing they could hold her hand to carry her through this time. If this was going to be COVID for our patients, I hated it.

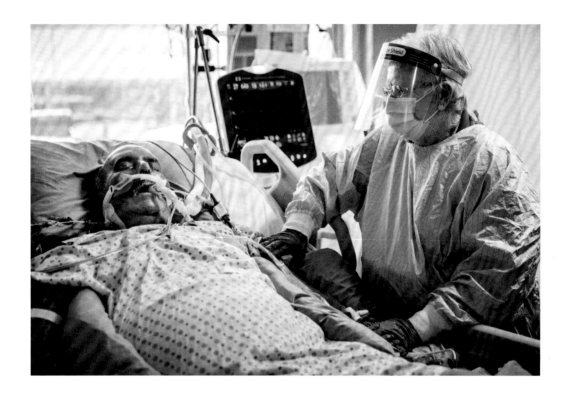

Dixie and Chuck

Dixie at the bedside of her beloved Chuck in the ICU. Dixie met Chuck in Calgary when she was fifteen. A few months later romance had bloomed — leading to marriage, three daughters, and a vibrant life together for over fifty-one years. Dixie and Chuck were infected with COVID in the winter of 2021, and Chuck became very ill. Dixie had a premonition when he left the house with the paramedics — she just knew he wouldn't be coming back.

Early on in Chuck's hospitalization, Dixie and Chuck were separated because of their active COVID infections; they spoke by video call just before he was intubated. After the infectious period was over, Dixie spent one hour each day in the ICU — the maximum visit length. She would moisturize his arms, legs, and face, read him messages and cards from family, and sit at his bedside. Their love and connection were evident in the way she spoke and in the gentleness of her touch. But Dixie was right. Despite his long, valiant fight with COVID, Chuck didn't go home.

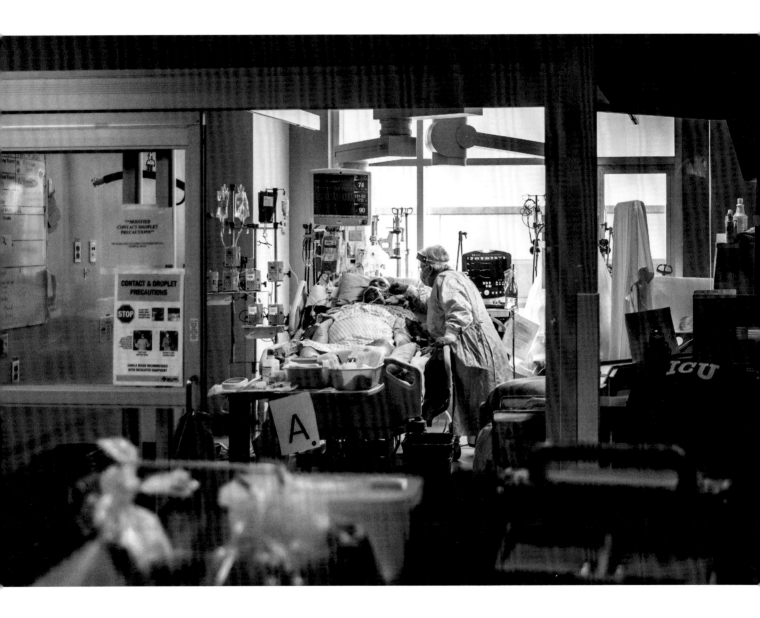

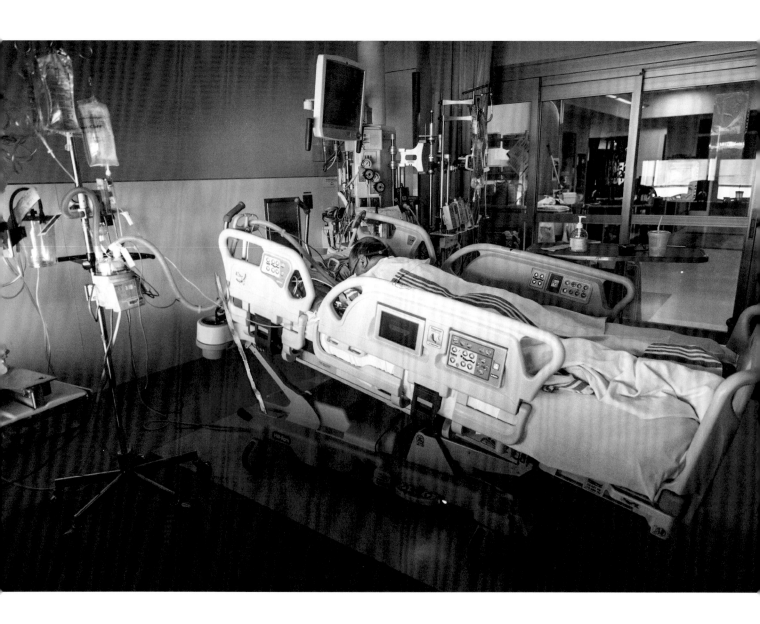

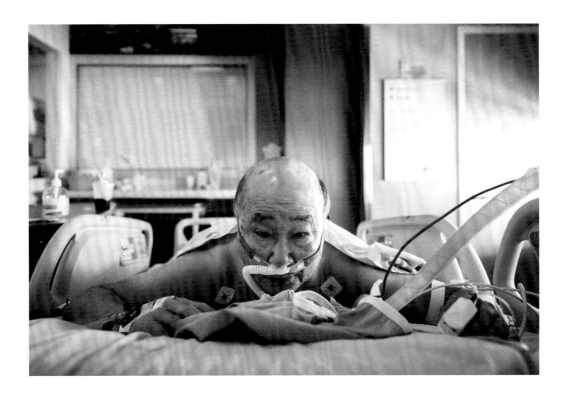

Self-proned

A patient in his seventies lies on his stomach in the ICU. He and his wife had visited his mother in hospital on the eve of her death. The next day, her unit was declared a COVID outbreak ward. Despite having followed all COVID guidelines, both he and his wife had been infected; now he was in hospital. With his oxygen levels dropping, despite near-maximal oxygen therapy, and his breathing getting more laboured, it seemed he was headed towards intubation. He was frightened as people streamed into his room, prepared equipment, and talked about his case. But then he was given another option — a new technique called "self-proning," which, at the time, was being studied internationally to determine if it could improve oxygenation and help avoid intubation.

It worked, but it was no fun. He breathlessly described how he couldn't sleep more than minutes at a time for over twenty-four hours. He lay awake, uncomfortable, and worrying — not only about his own health, but that he would miss his mother's funeral.

David

David speaks to his daughter before undergoing bronchoscopy, an invasive procedure to look directly at the airways in the lungs. Dr. Chip Doig, a critical-care (ICU) physician, holds the phone. David did not have COVID; his respiratory symptoms came from other causes. But he was one of countless patients whose experience of illness and health care was a more isolated one because of COVID. Due to public health restrictions, he hadn't seen his daughter or grandchildren for several months.

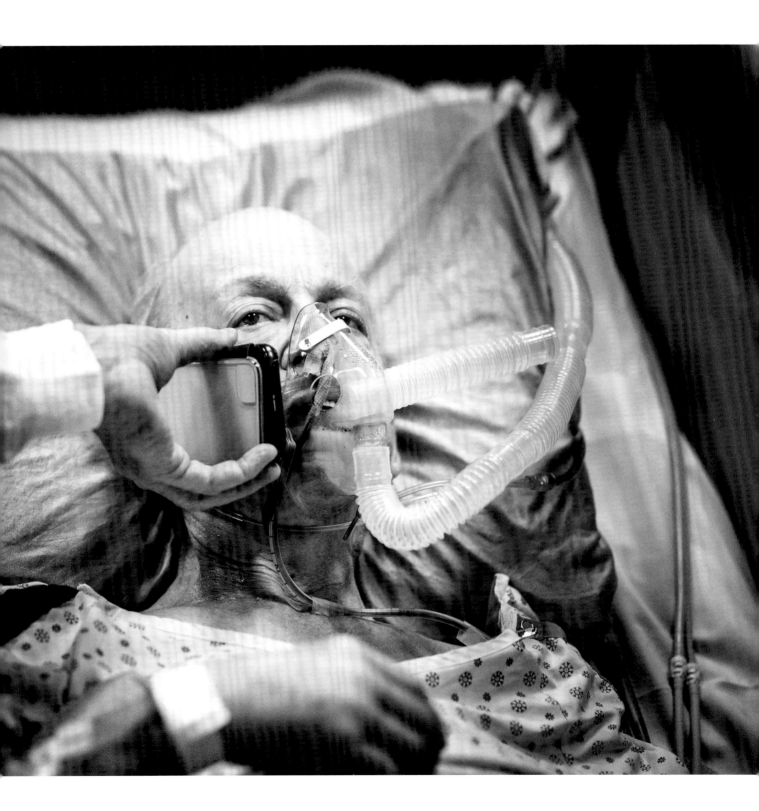

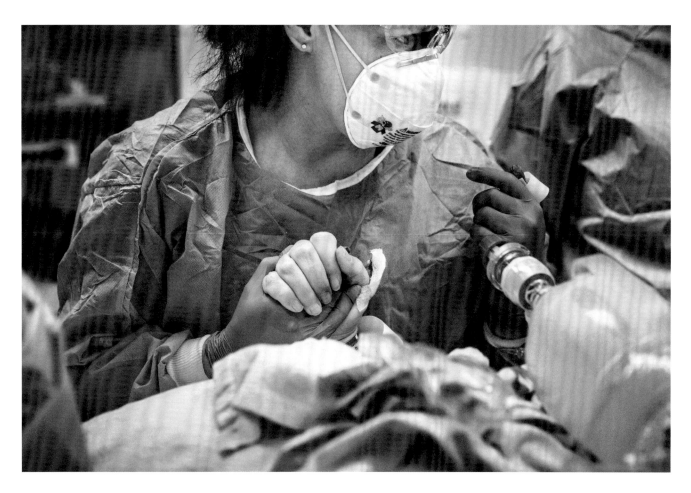

Lori Pollock, an emergency department nurse, and her patient, in the minutes before intubation. Moments of our shared humanity, woven into complex medical cases, reminded me of the balance of cognition and connection that drew me to medicine. I found astonishing scenes of empathy throughout the hospital, and it renewed my perspective on how we, as individuals and as a team, can provide care for others and ourselves during and despite the pandemic. COVID revealed the heart of those caring for the sick.

TWO
Pandemic Insight
Connection and Kindness

"I remember their names—the people who took care of me,
who held my hand, or helped me get up and walk."
 —Rob, a recovered patient

I brought my camera down from my eyes, startled by what I had captured. It was early January 2021, near the peak of the second wave. There was a bustle of activity in Trauma Bay 1 as the team of physicians, nurses, respiratory therapists, and health-care aides addressed the rapid change in their patient's condition. The rustling of gowns and crinkling of plastic coatings being stripped from face shields mingled with the sound of footsteps as more people arrived, the calling out of orders for medications, the persistent beeping of monitors, and the sound of drilling into bone. Then the room fell silent as team members paused, reviewed the plan, and then proceeded to intubate and stabilize the patient with medications, fluids, and ventilatory support. It all felt very normal, routine, if viewed with the standard emotional detachment. But in the critical moments before intubation, I saw my nursing colleague, Lori Pollock, holding the patient's hand, reassuring her that we would take care of her. It was a pivotal moment for me, a visual representation of the two sides of how we save a life—medical procedures and therapies, and warmth and compassion.

My younger sister, Ashleigh, wondered why I couldn't see this before. I explained that when I'm intubating or resuscitating a patient, it's my job to provide clear leadership, make safe and effective decisions, and carry out critical procedures. Intubation—the passage of a thirty-centimetre-long, one-centimetre-wide breathing tube into the trachea—is an intense, multi-step procedure that requires careful preparation and planning, plus, with COVID, additional focus on the safety

of the team. And with COVID, oxygen levels often drop precipitously during intubation. The body has minimal reserves. The tube must be placed just above the carina, where the trachea bifurcates (splits) into the right and left mainstem bronchus. It must be done quickly but also with precision. If it gets placed in the esophagus instead, this can be deadly if unrecognized.

After talking with Ashleigh, I wondered how people would react if they watched us intubate a COVID patient. Would they see the kindness first, or the large and terrifying tools and implements as we inserted the tube into the patient's mouth and advanced it into the trachea? Would they be shocked by watching as the patient was rendered unconscious and, shortly after, paralyzed by the medications that we delivered into their veins through IVs? Would observers understand the responsibility we feel as we hold that person at the brink of death — not breathing, not moving, dependent on our skill? And then I wondered what I would see during the next intubation I performed.

My renewed perspective propelled me to seek out moments that would illustrate this balance. And once I started, I found them everywhere: connection during tragic moments, tears and smiles shared simultaneously, joy amidst profound suffering. This recognition, just six weeks into my photography project, shaped how I would experience and photograph the pandemic moving forward.

(right) Dr. Lorissa Mews, an emergency physician, focused for intubation. It's an intense, multi-step procedure: administer medications — induction agent, paralytic. Pause. Position. Flex patient's neck and extend the head — the sniffing position. Open mouth. Insert video laryngoscope into oropharynx, along base of tongue and into vallecula. Use gentle forward and upward motion to expose vocal cords. Listen for monitors. Check oxygen saturation (sats). Suction secretions. Insert endotracheal tube with metal stylet into right-hand corner of mouth and advance until seen on screen. Adjust position. Advance through vocal cords. Withdraw stylet partially. Advance. Hold tube in place. Withdraw stylet. Inflate cuff. Listen to lungs. Check end-tidal CO_2. Check sats. Bag patient up. Listen to monitor beeping. Check tube location. Breathe. Watch sats. Check blood pressure. Attach ventilator. Sedate. Readminister paralytic. Check sats. Insert orogastric tube. X-ray chest. Transfer to ICU.

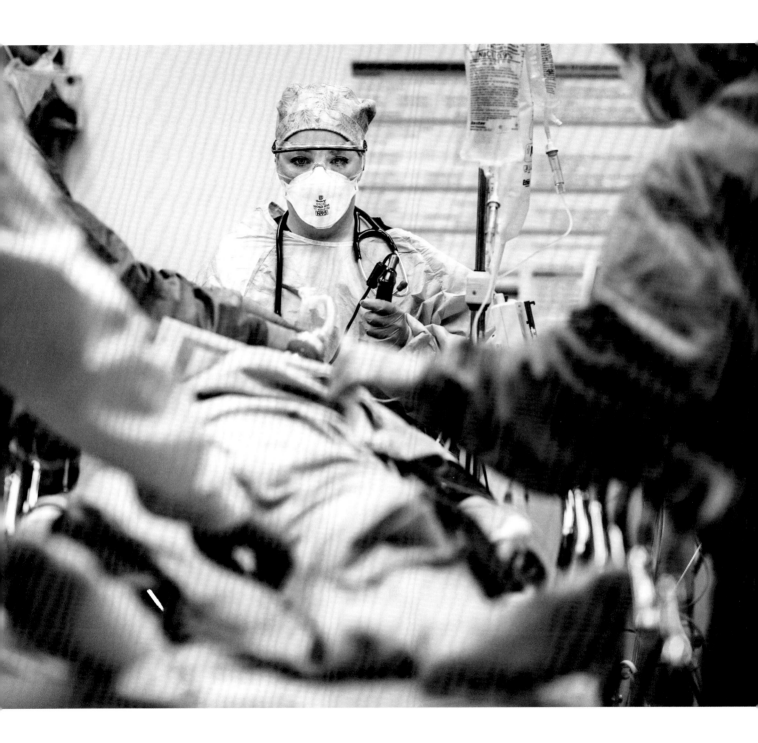

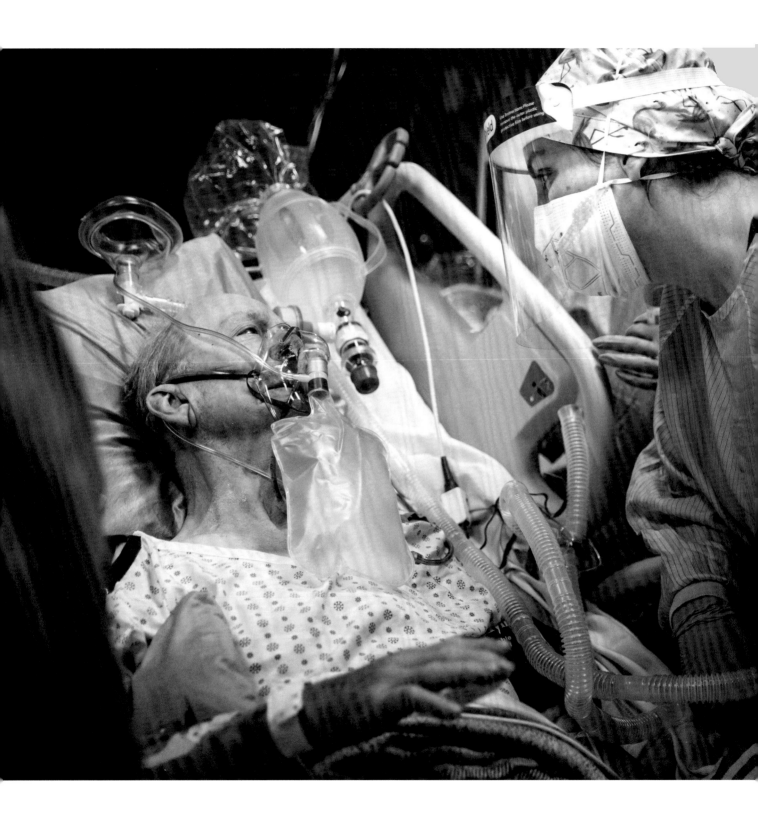

David, before intubation, with Melissa Vines, a critical-care nurse clinician. Alternating between performing intubations and photographing them gave me a deeper understanding of what the team and the patients were dealing with.

When I met David, I knew — and he and his wife knew — this didn't look good. After his bronchoscopy (see page 45), David continued to deteriorate clinically. Intubation was the only next step. He has a "guarded prognosis," is what we say to families — "maybe just a short time on the ventilator to get through the worst of it." But at the core, this translates to: it's time to say goodbye. "Just in case," we say, while we fight for the patient's survival.

Since David's COVID test had come back negative, his wife and daughter were able to be at his bedside before intubation. The beeping of monitors kept urging us to hurry, but still, the pace of the room slowed. These moments need time. Patients need time to understand. Families need time. So, we waited — together.

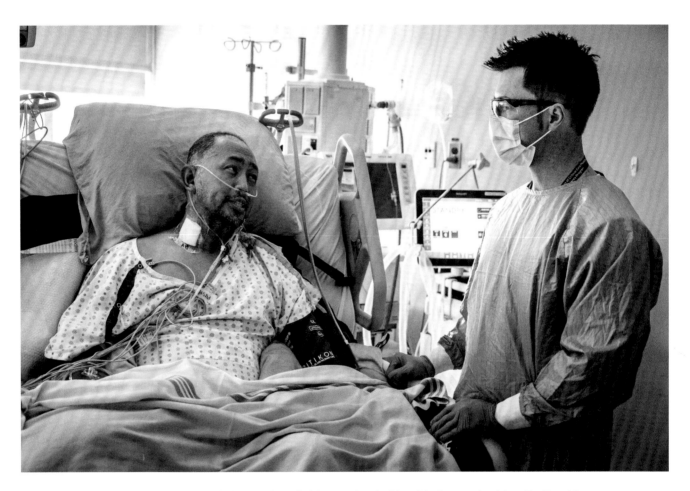

(above) A few hours after being extubated, this man thanks his critical-care physician, Dr. Dan Niven, for saving his life.

(opposite) Daniel Hughes, a volunteer who came to the ICU seven days a week to support staff and patients during COVID, wipes tears from a patient's eyes. The man's wife and children are about to arrive on a video call. Then, squeals of delight fill the room: "Daddy is awake! Daddy is awake!" It's the first time they've seen him since he was intubated a week earlier.

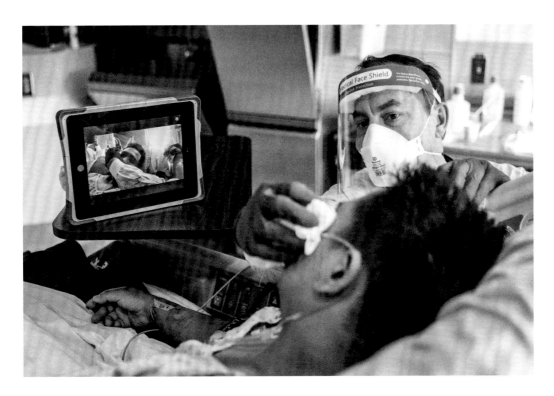

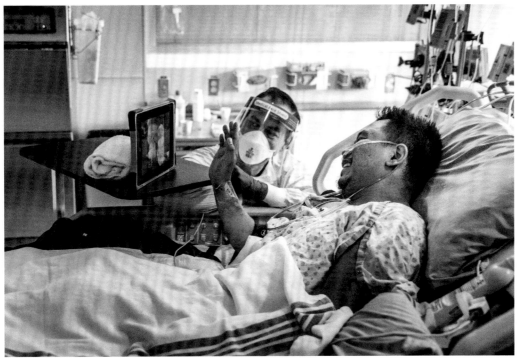

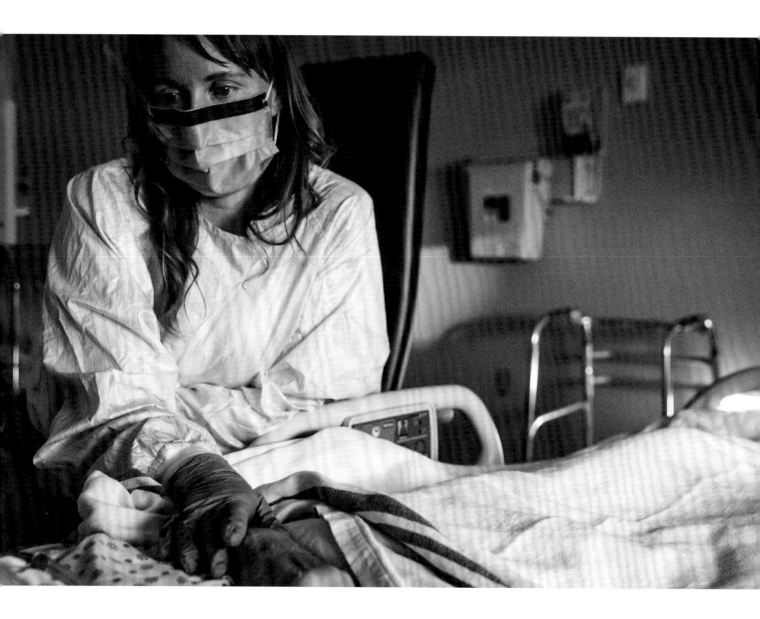

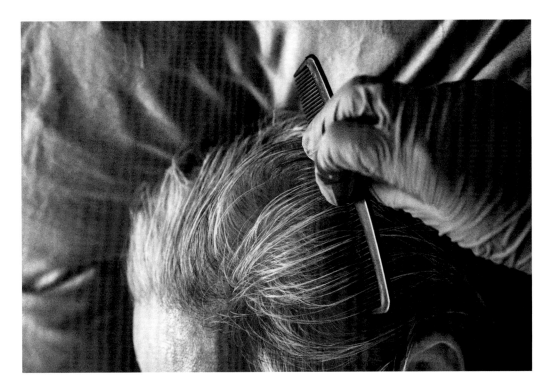

"Lead with your heart," Erica Foulds tells me, as we sit for the evening at the bedside of a dying woman. She has been volunteering with the No One Dies Alone program twice a week for the past two years, bringing companionship through touch, talking, singing, and reading poetry. Since 2016, this program has brought comfort to those dying in hospital without friends or family nearby. During COVID, the numbers increased because of loved ones who couldn't travel due to public health restrictions. At least three or four patients each week had a volunteer at their bedside during the last seventy-two hours of their life.

Watching as Erica combed the woman's hair, I felt a sense of peace. I allowed myself to experience the heartache of another loss, to take the time to feel it, instead of boxing it up and putting it in the closet of my soul with the memories of all the others I have witnessed taking their last breath. It was a relief to not have to proclaim "time of death," but instead to honour the life of a woman whose story I barely knew.

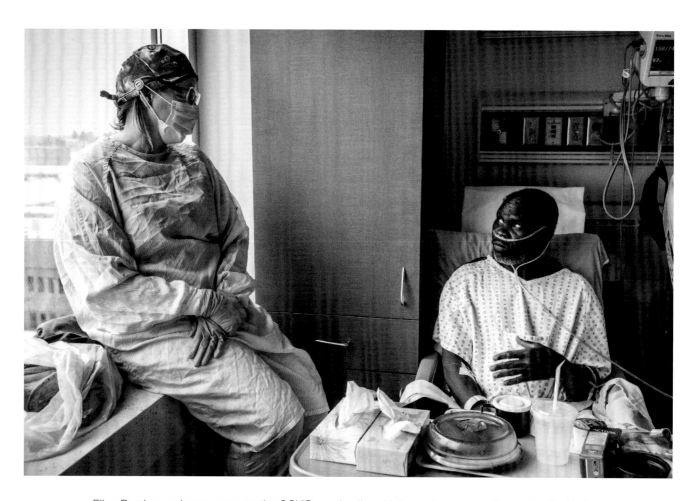

Ellen Brezina, a charge nurse on the COVID ward, talks with her patient about life and family. He has just moved from the bed to a chair — a simple activity, now profoundly difficult with COVID pneumonia. Earlier, he had expressed his worry that if he was unable to successfully move to the chair, it would delay his return to his family. Relationships formed during recovery had an enormous impact on patients and health-care providers both. Patient successes were celebrated together and often provided the energy for everyone to persevere.

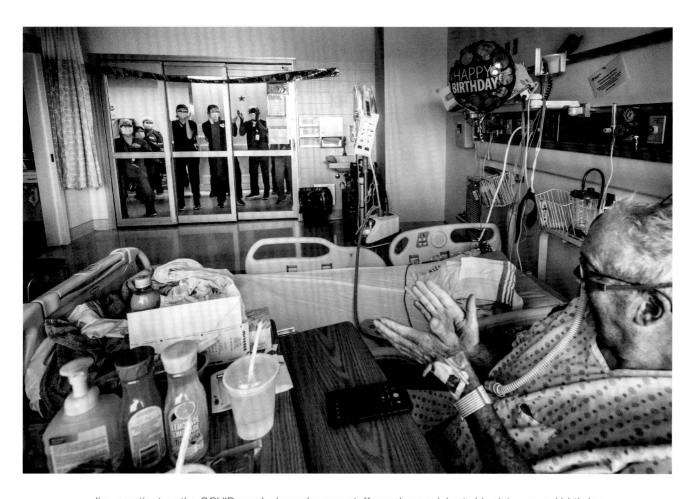

Jim, a patient on the COVID ward, claps along as staff members celebrate his sixty-second birthday by dancing and singing outside his isolation room. Smiles and laughter filled the room and corridor. Jim had joked that he wanted "dancing ladies" for his birthday. He didn't realize we were paying attention.

+

It took me time to see the lie that COVID tells us: "I am alone." It was time with patients and families, and in-hospital conversations with friends and colleagues, which led me to a sense of connectedness. I also came to see the balance that I needed. Not only did I want to offer kindness—I had to learn to receive it, even though, at times, to acknowledge that I needed support felt like an admission that I wasn't strong enough to carry the responsibility of being a physician during the pandemic. I started taking time to admire the children's pictures and crafts that filled our walls and their letters with endearing spelling mistakes. As I left the emergency department after a long, tiring shift, I watched Canada Post trucks drive laps around the hospital drop-off loop, honking their appreciation. I laughed out loud and waved. This changed the tone of my day—the demonstration of respect for front-line workers made me forget my exhaustion and, instead, celebrate my pride in being part of the team. Citizens often broke the monotony of the COVID lockdown by banging pots and pans on their balconies, doorsteps, and front lawns in every corner of the city, making sure we knew our work was appreciated.

Family, friends, and neighbours supported Kip and me at home. They delivered comfort food—mac and cheese, homemade chicken noodle soup, and hot bread paired with wine or our favourite IPA from Fernie Brewing Company. We licked the gooey goodness of homemade chocolate-chip cookies from our fingers while we played card games and laughed with our kids. We were given flowers to brighten our home. It all helped.

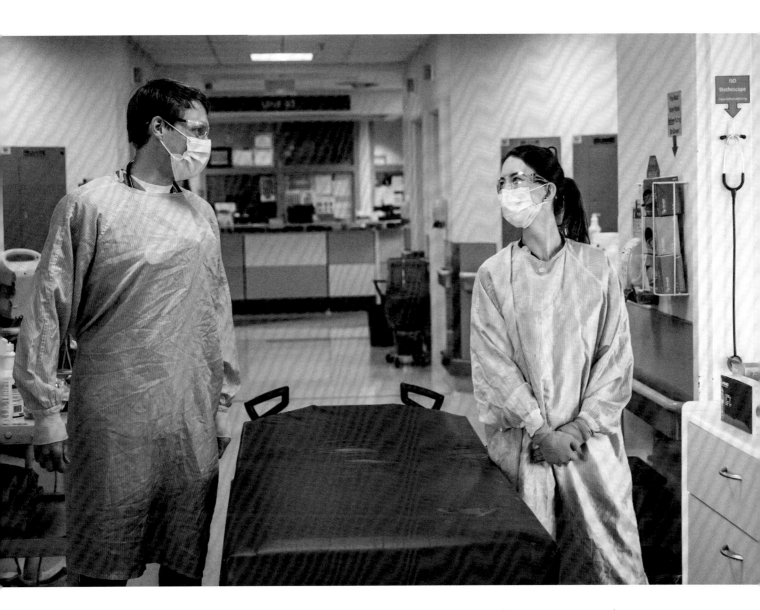

Dr. Ryan Lenz and Dr. Kasia Lenz share a moment before they enter patient rooms on opposite sides of the hallway on the COVID ward. Before COVID, this husband-and-wife team — an internal medicine specialist and an emergency physician — had never worked together.

Melissa Miller (far right) and her friends offer flowers and treats to front-line workers on a cold night as part of the Lois Project, named for Melissa's grandmother, a retired Saskatchewan nurse. Melissa gave me a bouquet as I left the hospital after an emergency department shift. A hairstylist, Melissa started the project — which ran for two months, across Alberta — after noticing that her clients from the health-care profession were "losing their sparkle" or were even at wit's end. She knew how that felt, having gone through her own struggles as the pandemic divided her from family and friends. At one point she lost her place of work — her "home away from home" — due to shutdowns. "One Saturday there was a protest a block away from my salon," she said. "I had a client in my chair who was a doctor, and I could tell that with every protester walking by she was becoming more and more discouraged. That's when I decided to do something. I wanted to show health-care workers that our community supports them."

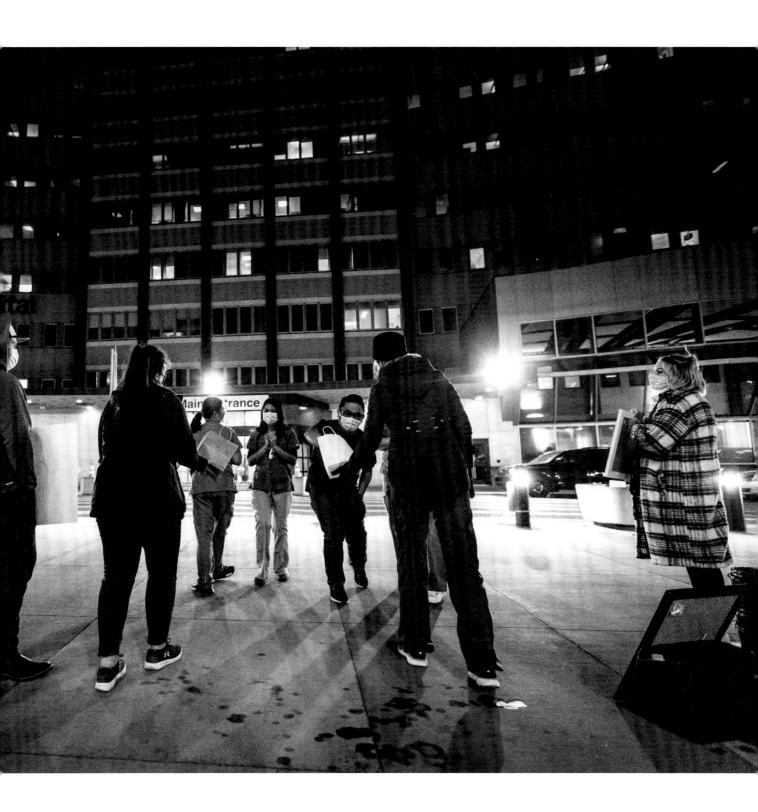

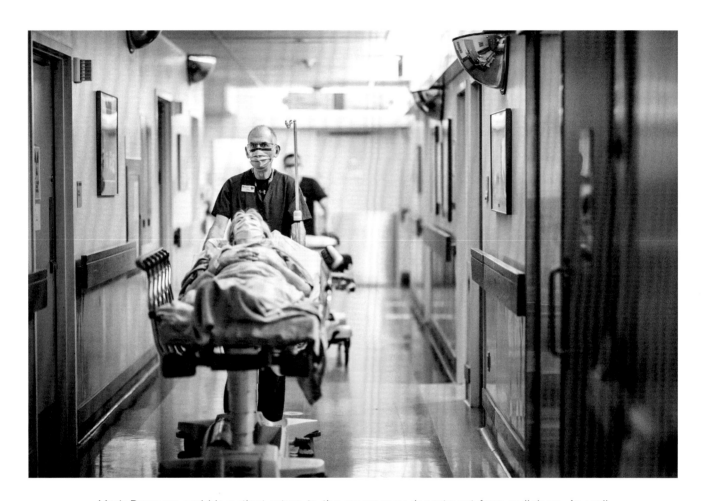

Mark Donovan and his patient return to the emergency department from radiology. As well as working as a hospital porter, Mark is a mediator for the Provincial Court in Calgary and Fort McMurray and teaches related courses at Mount Royal University. I'm sure he approaches all his jobs with the same zest for life — though maybe not the same running shoes. Mark has worked in various hospital roles for over forty years, starting in high school and continuing as he completed his B.A. and master's degrees while alternating child care and work hours with his wife, a teacher. "What unites all this diverse work for me is the theme and reality of helping people, one of my core values," he said, his warm smile barely contained by his mask.

THREE
Pandemic Insight
It Takes a Team

"It is the quality of our teamwork that has enabled us to get through the pandemic so far. It is the commitment of our teams and willingness to collaborate and innovate that will see us complete the pandemic response successfully. It is our belief in teamwork and willingness to adapt and grow that will ultimately leave us stronger."
— Michael Suddes, Site Director, Foothills Medical Centre

During the winter of 2021, while on my clinical sabbatical, I was amazed by what I was able to see with my camera. Instead of leaving the trauma bay to attend to the next patient in line, I now stayed long enough to see the aftermath: floors littered with blood-soaked gauze, gloves, and syringes. Our housekeeping staff, some of whom have worked in the emergency department for years, would spend the next hour cleaning—sometimes removing the remnants of a life we couldn't save. Wearing full PPE, they would scrub each surface of a room where a patient with COVID had been intubated and empty the bins full of contaminated equipment. Embarrassed by all that I hadn't had the time to notice before, I was no longer content to just say hello and a brief thank you. I asked them questions, learning their names and the names of their children. I wanted to get to know them and to recognize the unique skill sets required to care for our patients.

There are over thirty-one thousand general and clinical support-services team members in eighteen departments in Calgary. As I moved within these departments, I learned about some, such as Clinical Engineering, which I didn't even know existed. I witnessed excellence, innovation, and often sacrifice. I realized that each team and each person is essential for the end goal of providing care for our patients. And in this exploration to discover our complete team, I felt such gratitude.

Davinder Kaler, a housekeeper in the emergency department for seven years, cleans and disinfects equipment. She can be spotted with her long dark hair tucked into a beautifully patterned scrub cap while preparing clinical spaces to receive the next patient. Davinder knows that her role is essential and speaks with pride about her work. "COVID has been hard for the whole family," she said. Early in the pandemic, her husband was stranded in India for five months when international flights were cancelled. When he returned, his work as a taxi driver was put on hold due to public-health restrictions. How was I only just meeting this lovely woman who is an essential part of our emergency department team?

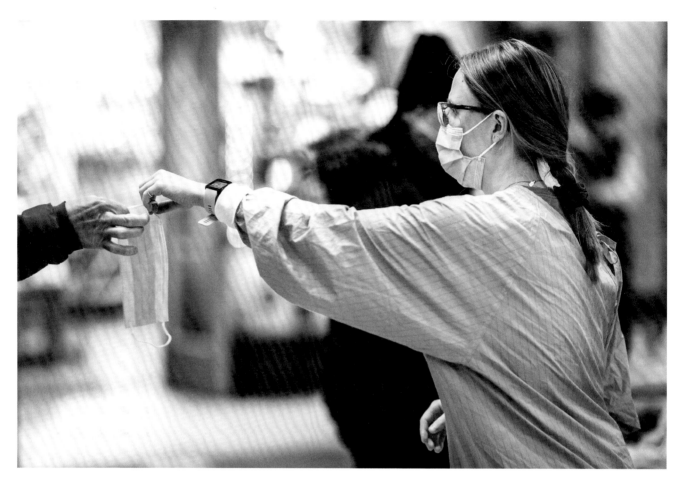

Olivia Hunter hands out a mask at the hospital entrance. About fourteen thousand masks are distributed daily at this facility alone. The Entrance Team of nearly three hundred people — many of whom work in their usual roles as well — are responsible for screening visitors and incoming patients for COVID symptoms and for distributing masks and hand sanitizer. In a single day they meet about fifteen hundred new patients or people arriving for appointments, fifteen hundred designated support persons, and eleven thousand staff.

Olivia is a nurse on the thoracic surgery and pulmonary medicine ward as well as a team lead for the Entrance Team, a role which she says has given her an appreciation for the coordination it takes to run a hospital. "Working with the Entrance Team has taught me many valuable lessons that I take into my clinical role as a nurse. I have learned to be flexible in the face of ever-changing policies, how to de-escalate those who are upset, and to be compassionate towards others even in extremely difficult situations. The longer the pandemic lasts, the more proud I am to be part of such a strong and resilient profession."

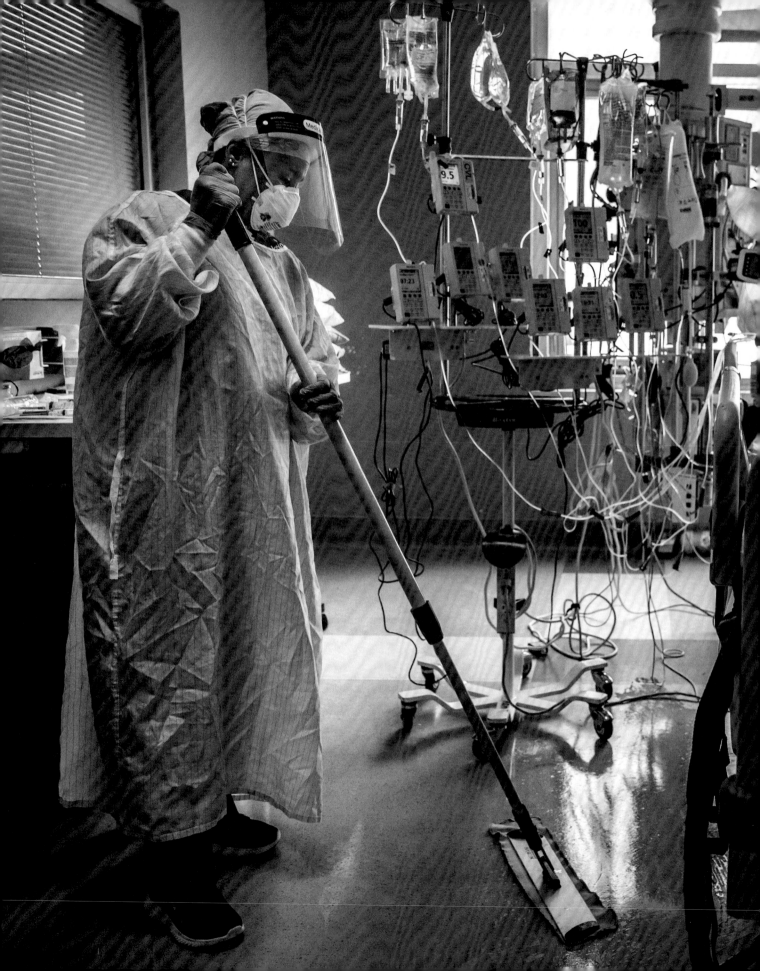

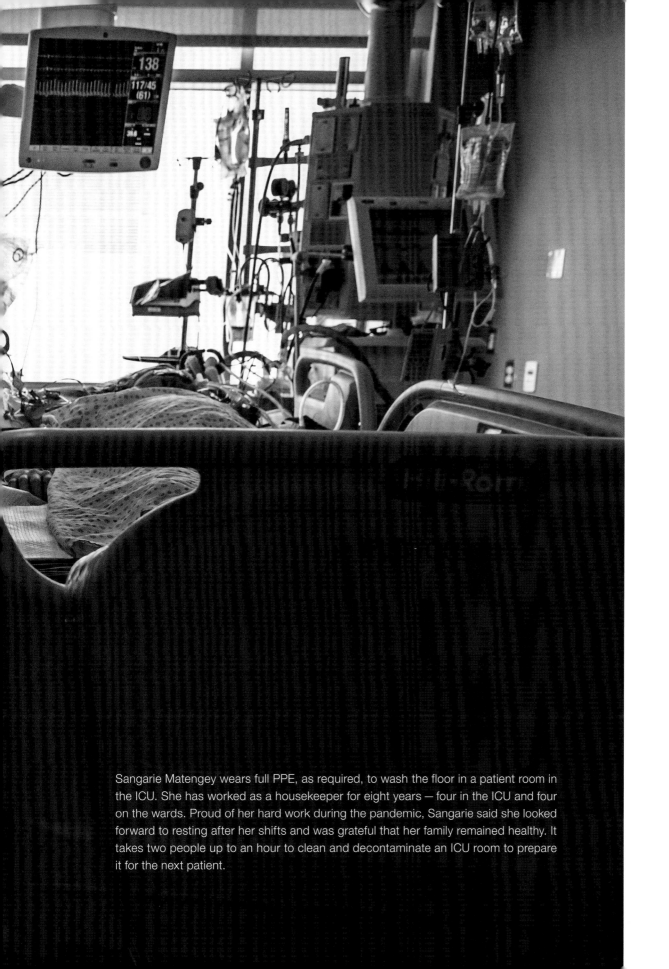

Sangarie Matengey wears full PPE, as required, to wash the floor in a patient room in the ICU. She has worked as a housekeeper for eight years — four in the ICU and four on the wards. Proud of her hard work during the pandemic, Sangarie said she looked forward to resting after her shifts and was grateful that her family remained healthy. It takes two people up to an hour to clean and decontaminate an ICU room to prepare it for the next patient.

(above) Medical lab technician Ayed Saad, at work. Ayed processed the swab for the first case of COVID in Calgary — something he says he will always remember. He and his team at ProvLab (Alberta Health Services' Public Health Laboratory) were initially responsible for all COVID test processing in southern Alberta. They worked overtime for months, trying to keep up with the deluge of tests in hospitals and the community. In their basement lab, the crowded hallways were lined with shelves full of tests ready to be processed. Early in the pandemic, Ayed worked thirty consecutive days, and he limited his contact with his family to keep them safe. He knew his work directly impacted the speed of COVID test result reporting, subsequent contact tracing, and transmission.

(opposite) Win Oo of the Clinical Engineering department, in his office adjacent to the ICU. Win has worked here since 2009 and is responsible for all of the equipment in the ICU. The pandemic nearly doubled the amount of equipment for patient care — and his workload. When necessary, Win would wear full PPE to do repair work in patient rooms — something he found particularly challenging, since he often needed to crawl underneath cables and equipment. In April 2020, as COVID numbers increased, Win was presented with a bigger challenge. He and a group of colleagues — Nisha Madan, Shiv Dave, and Carl Vandrasco, all from Clinical Engineering, and Randy Pearton from Facilities Maintenance and Engineering — were asked to find a way to safely monitor two patients per ICU room. This had never been done before. They had three days. Together they built a system that increased the capacity of the ICU from thirty-six to the needed sixty beds. When Win's wife asked why he would work in the ICU instead of in another, safer location, he responded, "I just want to help the clinicians and patients."

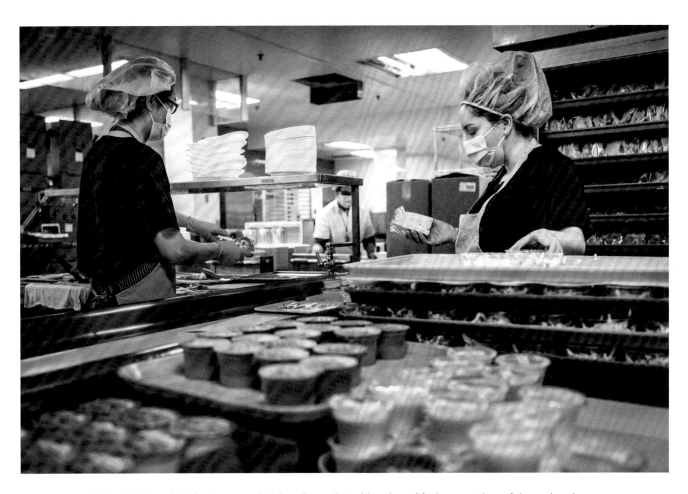

Maria Orellana (right) plates sandwiches for patients' lunches. Maria, a mother of three, has been working in patient food services since 2009. She finds it satisfying to know that it directly impacts patients' health and recovery. Many areas of the hospital faced increased workload as a result of COVID. At this site alone, the in-patient food services team provided 3,300 hand-delivered meals and 2,200 snacks daily.

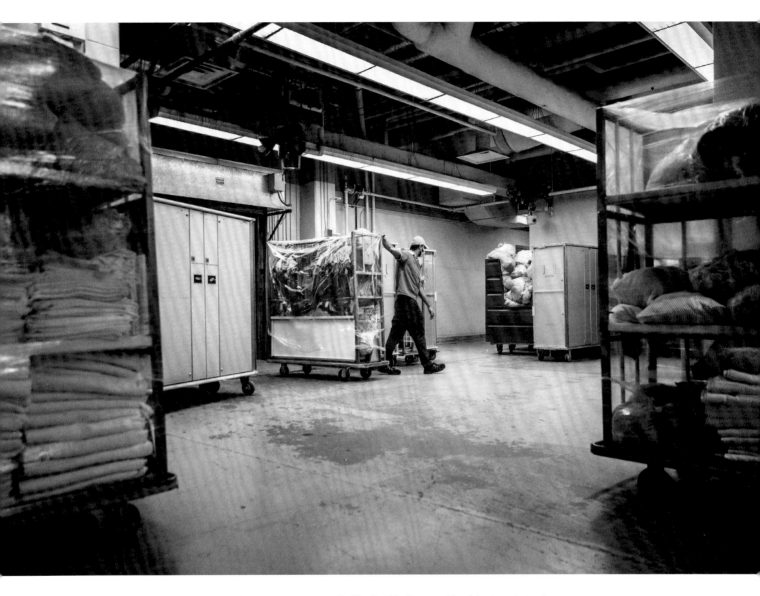

Pawan Sapkota unloads a transport truck filled with linens. I had just watched an emergency department team prepare for the arrival of a COVID patient. As one person after another pulled a yellow gown from a linens bag and donned their PPE, I wondered — who delivers the thousands of gowns we use daily? How had I not thought about this before? I found myself in the basement of the hospital in the linens department where workers deliver the gowns, scrubs, and linens that were now being used in unprecedented numbers — more than doubling their usual workload. Pawan is also a talented photographer. While we waited for the next transport truck to arrive, he showed me some of his work, including gorgeous photos of his homeland, Nepal. He felt proud to be an essential worker in the hospital and happy that he was helping to keep staff and patients safe.

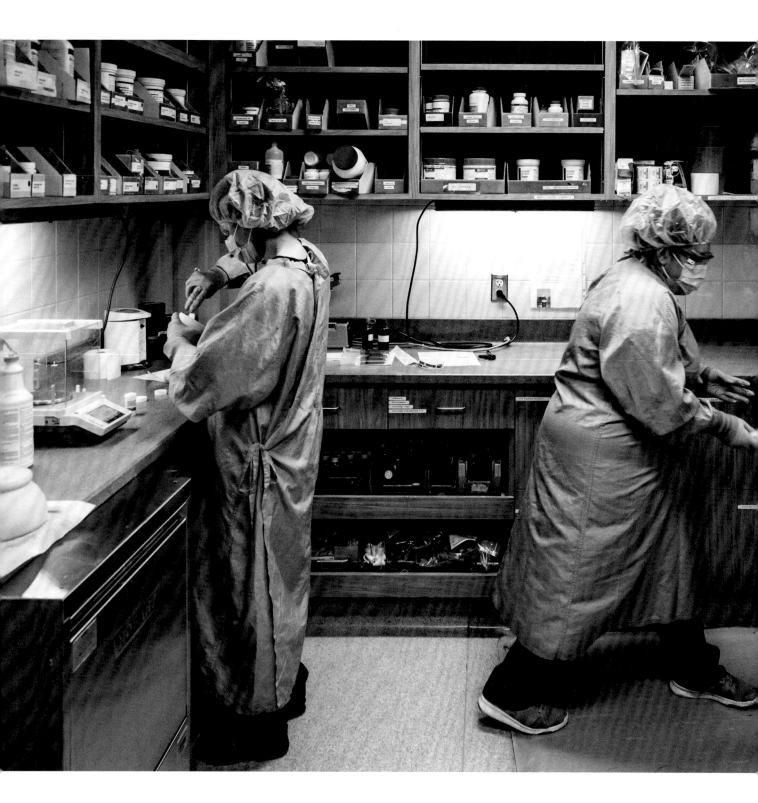

Pharmacy technicians Pamela Grant (left) and Jaden Avila wear full PPE as they compound prescriptions for hospital patients. Mandeep Plaha, the director of pharmacy and a hard-working mother of two, introduced me to her team with the pride I would expect if I were meeting her family. She explained the process, starting with receiving and confirming prescription requests for the delivery of medications to each unit. Her team filled about five thousand prescriptions daily and stocked units with key medications. They also refilled crash carts with resuscitation medications for cardiac arrest, which were used up much more quickly than usual during COVID. During the next cardiac arrest I was involved with, I mentally thanked those who made sure the medications were available for my patient.

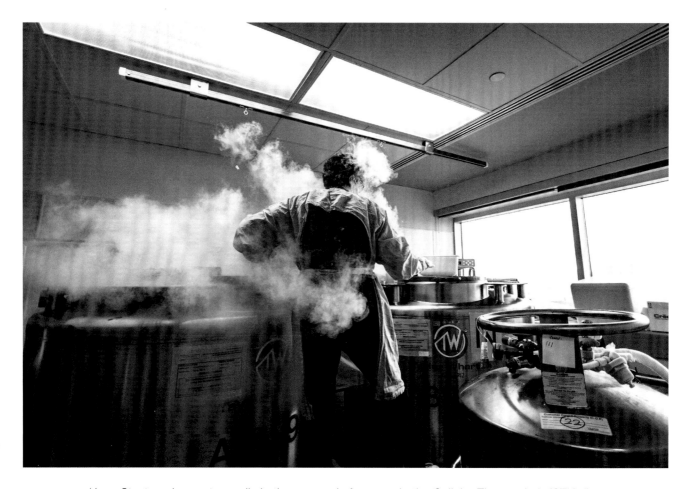

Hana Stastna places stem cells in the cryogenic freezers. In the Cellular Therapy Lab (CTL), Dr. Nicole Prokopishyn and her team — Hana, Susan Berrigan, April Hillman, Nadine Favell, and Carol Chambers — ensure that Albertans are able to receive this life-saving therapy. The lack of international flights during the pandemic threatened to disrupt their ability to provide stem-cell transplantation within the required seventy-two-hour window from time of donation. Special permission was granted to have stem cells carried by hand from the country of origin, but the couriers were unable to bring them to the hospital due to possible COVID exposure. For six months, Dr. Prokopishyn picked the cells up from the couriers herself, at all hours of the day and night, and delivered them to the lab where her team was waiting, ready to prepare them for transplant.

CTL is part of Alberta Precision Laboratories, whose goal is to provide ongoing, uninterrupted, excellent patient care. During the pandemic, their innovative solutions included delivering treatments and medications to patients at home and developing systems to ensure access to blood for transfusions across the province — while simultaneously supporting academic research to improve our understanding of COVID.

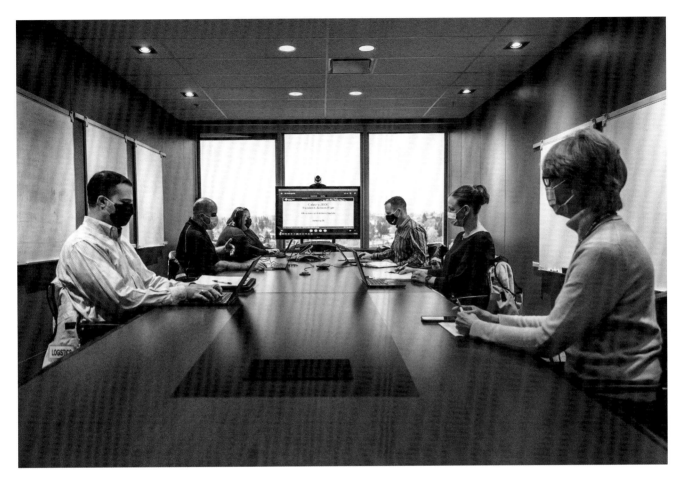

(clockwise from left) David Silverstone, Ken Hoffer, Briana Tibbatts, Nick Thain, Christine Guss, and Dr. Laurie-Ann Baker are part of ZEOC — Calgary's twenty-seven-member Zone Emergency Operations Committee. Committee members would meet to discuss and manage the multitude of tasks related to the pandemic response in the Calgary zone. During the busiest times they met up to seven days a week, either virtually or in person depending on public health restrictions. As a physician facing the uncertainty and evolving understanding of COVID, I felt more confident knowing they had my back.

Dr. Baker, an emergency physician and ZEOC's medical director, talked about some of the unanticipated challenges: "Truly the landscape has changed for many of us, and leadership has not been immune to the many 'hits' and a resulting vulnerability." With the support of her wife and two children at home, Dr. Baker worked closely with ZEOC co-chair Nick Thain, a senior operating officer at AHS. Together, they made and carried out many difficult decisions that were needed to keep patients, staff, and the community safe.

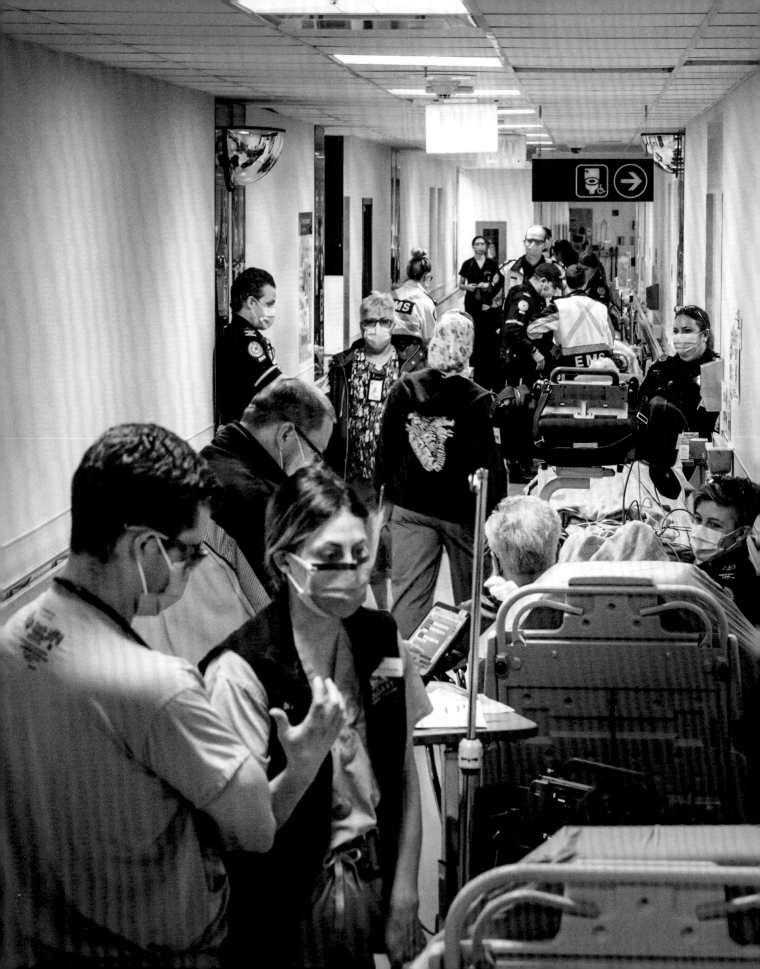

FOUR
One Year In
A Hopeful New Normal

"I wish that I could convince everyone to get vaccinated;
then, this will be over."
—Quinn Rodgers, age 12

By winter 2021, Canada had lived with the pandemic for almost a year. In Calgary, we were just past the peak of the second wave, but there was a distinct sense of change. While the emergency departments, wards, and ICUs were still busy with COVID patients, case numbers in the community were falling. We knew our numbers in the hospital would follow suit. A vaccine was on the horizon. We carried on with our day-to-day work, thinking this would soon be over.

In time, there were indeed fewer COVID resuscitations and intubations and more patients arriving in the emergency department with illnesses other than COVID. There were, however, many reminders that the pandemic was not yet through with us.

(opposite) A busy day in the emergency department. Stretchers spill over into adjacent hallways, with patients being cared for by paramedics while waiting for beds. Seeing an influx of non-COVID patients in the hospital was a huge change after the first wave of the pandemic, when people were afraid to come in.

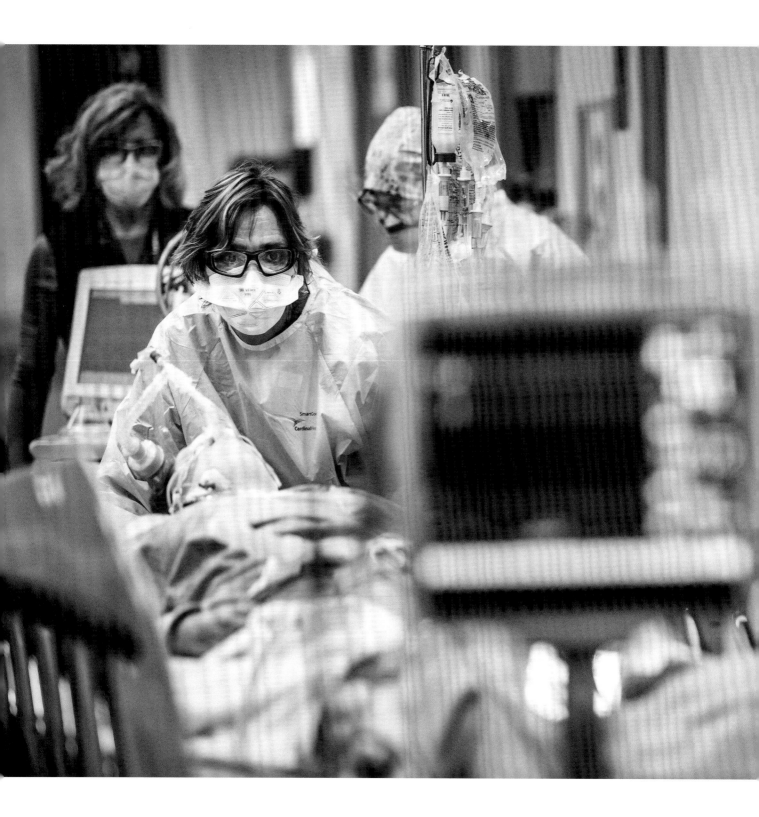

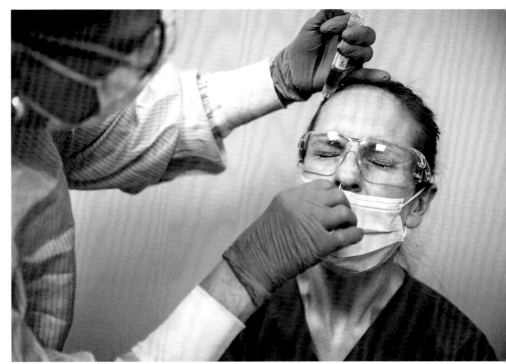

(above) Dr. Jennifer Nicol receives her COVID test from nurse clinician Terri Roth. On this same day, I received my seventh test. All emergency department staff had to be tested after several staff members acquired COVID at work and the department was declared an outbreak unit.

(left) Wendy Ost, a health-care aide in the emergency department, urgently transports an intubated patient without COVID to diagnostic imaging for a CT scan. Odd though it may sound, taking care of patients with non-COVID illnesses felt like a reprieve to me, a return to what we know and what we were used to. So this hopeful new normal was something I deeply appreciated, after all the faces and painful stories of those with COVID whom we couldn't save.

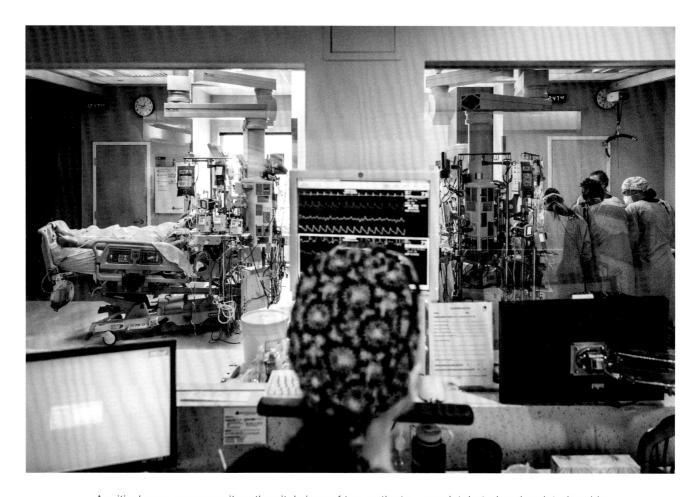

A critical-care nurse monitors the vital signs of two patients — one intubated and sedated on his back, the other urgently being placed in the prone position due to critically low oxygen saturation. The ICU remained busy with COVID patients; declining case numbers in the community were not yet reflected in hospital admissions.

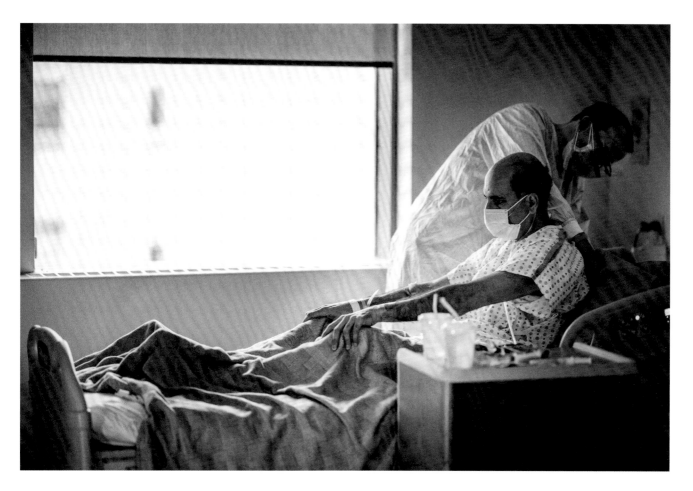

Dr. Sylvain Coderre examines his patient, who is one of thirteen in his family to be infected and one of four to be admitted to hospital. He expressed his gratitude to staff. "According to my belief, the people who serve humanity...God will reward them." During this time in the pandemic, it was common to see entire families infected.

A multidisciplinary team — nurses, health-care aides, and respiratory therapists — settle a patient into the ICU. Anyone whose primary responsibilities fell outside of COVID could be found helping on COVID wards or ICUs, sometimes in addition to their regular roles.

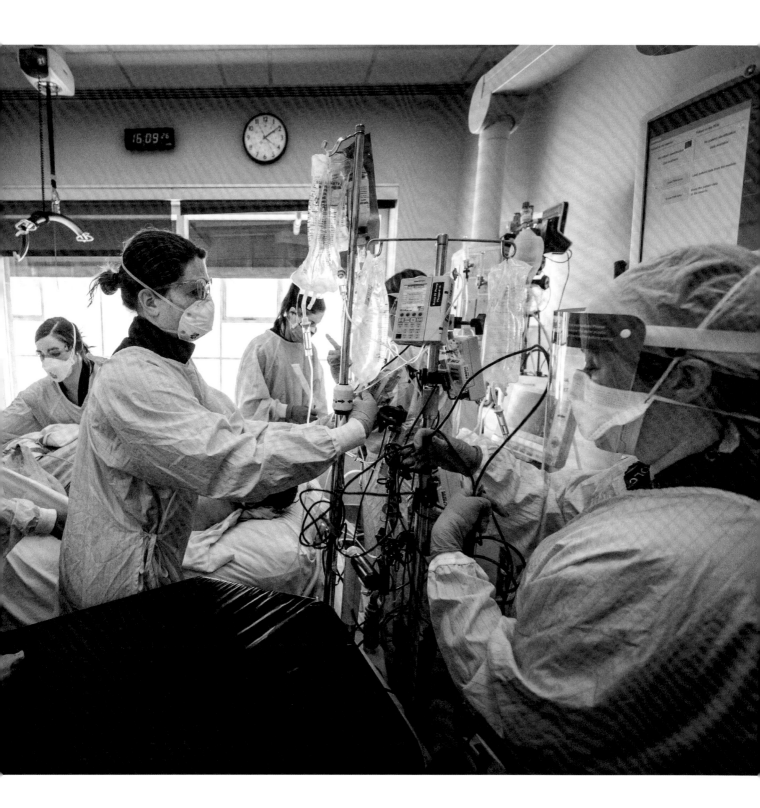

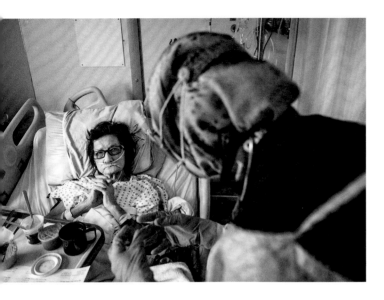

Dr. Hanan Bassyouni, a redeployed endocrin-ologist on the COVID ward, tells her patient that she has stabilized and can be transferred to her local hospital to recover. After listening intently, the patient asks detailed questions and then, with smiles and laughter, shares photos of her children and grandchildren.

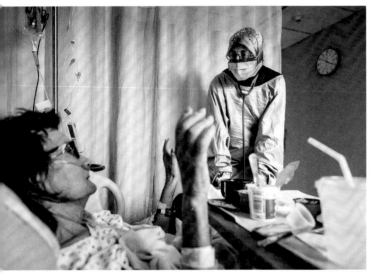

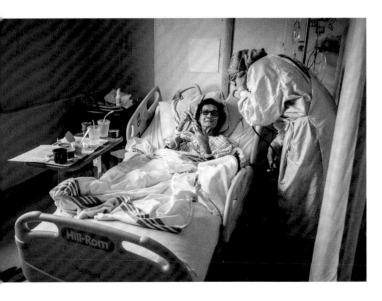

As I photographed, I was struck by a positive change within the culture of medicine. We all start out with a similar and maybe clichéd goal of altruism and a desire to help others, but division happens quickly. We often boast that we know who a medical student will become when we meet them. We sort them into categories—calculating surgeons, brainy internists, introverted radiologists, quirky psychiatrists, and fast-thinking emergency physicians. The sorting creates an "us and them" culture of separation. It leads to generalizations, criticism, blame, and, at times, unprofessional interactions.

During the pandemic, there appeared to be a return to the common goal, a setting aside of our differences. People who may not have worked side by side since medical school or residency came together on the ICUs and COVID wards: critical-care physicians, pediatric and adult emergency physicians, family physicians, surgeons, anesthesiologists, internists, cardiologists, endocrinologists, nephrologists, respirologists, geriatricians, rheumatologists, hematologists, and gastroenterologists. The medical world celebrated all of our unique strengths, working together to care for our patients. Perhaps it took a crisis like COVID to remind us that we're all on the same team.

+

When staff vaccination clinics had opened across the city in late December 2020, there was a palpable sense of hope mingled with our fatigue. It was a welcome change. I photographed Dr. Philippe Couillard and Dr. George Alvarez, critical-care physicians, receiving their first dose. Dr. Couillard was the first person I met sixteen years ago when I moved to Calgary for residency. We shared photos of our children while he stood in the lineup of health-care providers waiting to take their turn. We talked about the pandemic—especially the number of people who had died and the impact on all of us. He spoke of his sense of relief knowing he would be protected, and of the comfort it gave his family.

I also photographed vaccinations in the community. For me, the magnitude of the Calgary TELUS Convention Centre site provided a dramatic visual of the optimism our community felt. One hundred and twenty vaccination stations were staffed by physicians, nurses, dentists, paramedics, pharmacists, and support staff. Lineups reminiscent of Disneyland snaked for over a kilometre, with 402,401 people vaccinated at the site, including a record-breaking 13,390 vaccinations in a single day. Citizens celebrated with smiles, high fives, and even costumes.

Critical-care physician Dr. George Alvarez can't contain his excitement after receiving his first dose of the COVID vaccine. Never before had I seen people embrace the anticipated symptoms of vaccination. "I'm going to smile through my fever, headache, and myalgias, knowing that I will not be in the ICU infected with COVID," remarked one health-care worker.

Sadly, though, the first hints of the politicization of vaccination started to appear. Some people struggled with why they weren't first in line, or second, or with which vaccine they would receive. In the hospital setting, some interpreted their wait as a value statement about their contribution to patient care. While that was certainly not the intention, petitions circulated and comparisons of vaccination dates were often laced with feelings of personal insult.

Regardless of how people felt about waiting, the day of their vaccination was universally joyful.

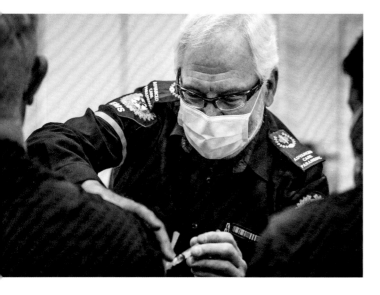

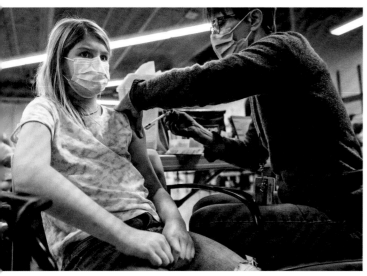

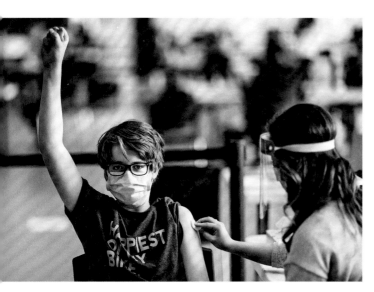

(top to bottom) Don Sharpe vaccinates a Calgarian at the TELUS Convention Centre. An advanced-care paramedic with Emergency Medical Services (EMS), Don was redeployed to the public health department during COVID. After forty years on the job, he's no stranger to fast-paced or stressful situations. In 2019, he and his EMS partner, Ben Rempel, received the Calgary Police Service Award of Exceptional Recognition for Valour for intervening in an assault. Still, Don said he felt intimidated on his first day of vaccinating. Colleagues reminded him that he wouldn't be nervous responding to something more difficult, such as a cardiac arrest! Don continues to be part of the pediatric immunization team. He loves meeting the families and the children, whom he describes as "a blessing to be around." He keeps the drawings and notes they give him.

My nine-year-old daughter, Hannah, like most other children, obviously doesn't love getting a vaccine. She was quiet on the car ride there, but on the way home she started planning family get-togethers, anticipating birthday parties and a family trip to the Wizarding World of Harry Potter.

My twelve-year-old son, Quinn, celebrates after he receives his first vaccination at the TELUS Convention Centre.

At home, life was starting to feel almost normal at times. The province introduced a framework for easing restrictions, called "The Path Forward," allowing outdoor gatherings of fewer than ten people. We welcomed the chance to reconnect with friends and family on walks in the neighbourhood park — or to sit physically distanced in the driveway on camping chairs. We were able to go skiing as a family and restart our tradition of après-ski nachos and card games outside on the patio.

But the realities of COVID were still present. Classroom exposures landed Hannah in mandatory isolation for two weeks and made both kids worry about getting the virus at school. We tried to make it a painless experience, but no amount of movies and treats could erase the ongoing challenges in our efforts to carry on with this new normal. I tried to be present, to appreciate the small things each day. But I was waiting to be done with COVID.

The day finally arrived for some of my family members to be vaccinated. As I photographed my parents and children, I felt profoundly grateful to all those who were involved in the development and distribution of this life-saving technology. I also felt a lightness to my mood as I started to let myself look forward to Sunday night family dinners and birthday parties, to Easter and Christmas dinners together, and to the chance of travelling to see my ninety-one-year-old grandmother and extended family in Toronto and Victoria.

The end of the second wave felt like a celebration. There was a sense of accomplishment as we congratulated ourselves on winning the battle, persisting through the challenges, and overcoming our fears. I was optimistic.

It was short lived.

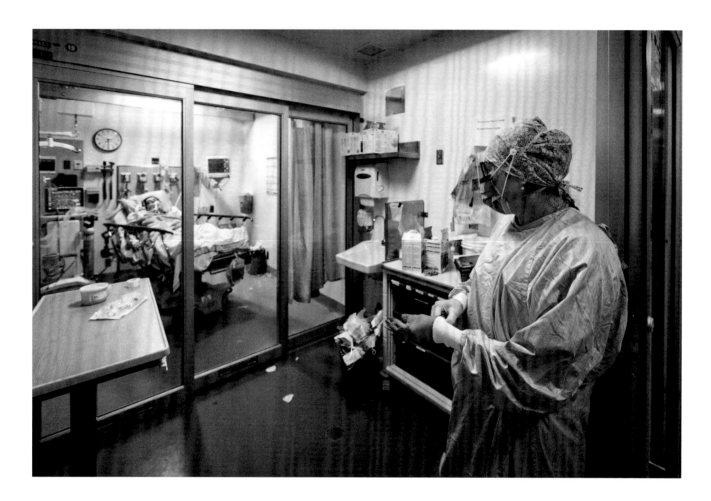

Ren Teng, a respiratory therapist, prepares to re-enter her patient's room in the emergency department. Despite intubation, this patient had ongoing hypoxia (low oxygen levels). Just moments before, Ren had left the bedside of another critically ill intubated patient with COVID. In hushed voices at desks in the emergency department, physicians were now sharing stories of recent patients, young and otherwise healthy, admitted to the ICU. Some were nearly dead. Others had already died. Is this really happening? we would ask. Did you hear about the case yesterday? On April 6, the provincial government announced we were officially in the third wave, with case numbers averaging more than one thousand per day. This was mere weeks after our numbers had stabilized at two to three hundred cases daily.

FIVE
The Third Wave
It's a Tsunami

"In the race between vaccines and variants of COVID-19,
the variants are winning."
— Premier Jason Kenney, news conference
April 1, 2021

The relentless nature of COVID revealed itself in Calgary's third wave, which was plagued with more aggressive variants. With my sabbatical over, I was now working in the emergency department and photographing on my days off. I struggled to find the optimism that I had so recently, naively, felt.

A page from my journal in early April, after a day of photographing in the ICU:

I can't sleep tonight. My COVID insomnia has resurfaced. It's 00:15 and I am exhausted and yet sleep evades me.

Today I witnessed the third wave. The ICU was full, full of people in their twenties, thirties, forties, fifties, and a few sixties to eighties. It was staggering to see it happening again and it feels so much worse. Why? Perhaps because it has been so long, because we are here on the brink, the precipice again, because I am tired of seeing the suffering, because I so badly want this to be over.

Maybe by putting it down on paper it will help me process the tragedy so that I can go back to work in the emergency department tomorrow, ready for the battle.

Today I saw the new faces of COVID:

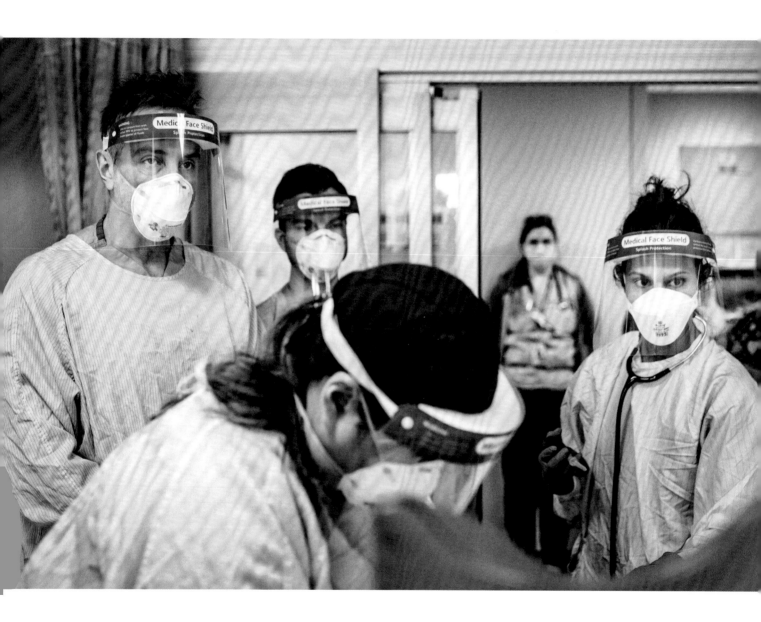

I saw parents visiting an adult child who will have no meaningful recovery. They were so young.

I saw a daughter who already lost a member of her family to COVID today, standing at her dad's bedside, hoping for a miracle, refusing to give up.

I saw a man saying goodbye to his family on Facetime before intubation, terrified, resigned.

I saw a man in his forties, extubated that morning, who was so weak that he was unable to lift his arms. Even speaking was an enormous effort. Like she did for so many others before him, his nurse washed his face and brushed his teeth.

I saw a family from out of town slowly putting on their PPE. They had arrived too late to say goodbye.

I saw MDs, nurses, RTs, and health-care aides who fought for the life of their patient and won, but only for a few hours.

I saw dark circles under their eyes, heard stories of how hard it is to keep Facetiming loved ones to allow patients to say goodbye before being intubated.

I saw tragedy. I saw exhaustion and burnout.

(opposite) Dr. George Alvarez (far left), a critical-care physician, and Dr. Ayesha Khory (far right), a redeployed emergency physician, work with the ICU team to resuscitate a COVID patient in cardiac arrest. Vaccination had started in the community, but most patients had not yet had theirs. Once the stream of patients began, it didn't stop. Designated COVID areas overflowed in the emergency department, COVID wards were expanded, and new admissions to the ICU often outpaced both recoveries and deaths. The more aggressive variants were appearing internationally and, inevitably, in Canada as well.

(overleaf) The view from the head of the bed as the ICU team resuscitates a patient with COVID during cardiac arrest. The old mantra in medicine of "put your head down and work harder" didn't seem to apply any longer. We had given everything we had, and this continued onslaught of critically ill patients left the team struggling to keep up morale, to find the emotional reserves to continue this critical work.

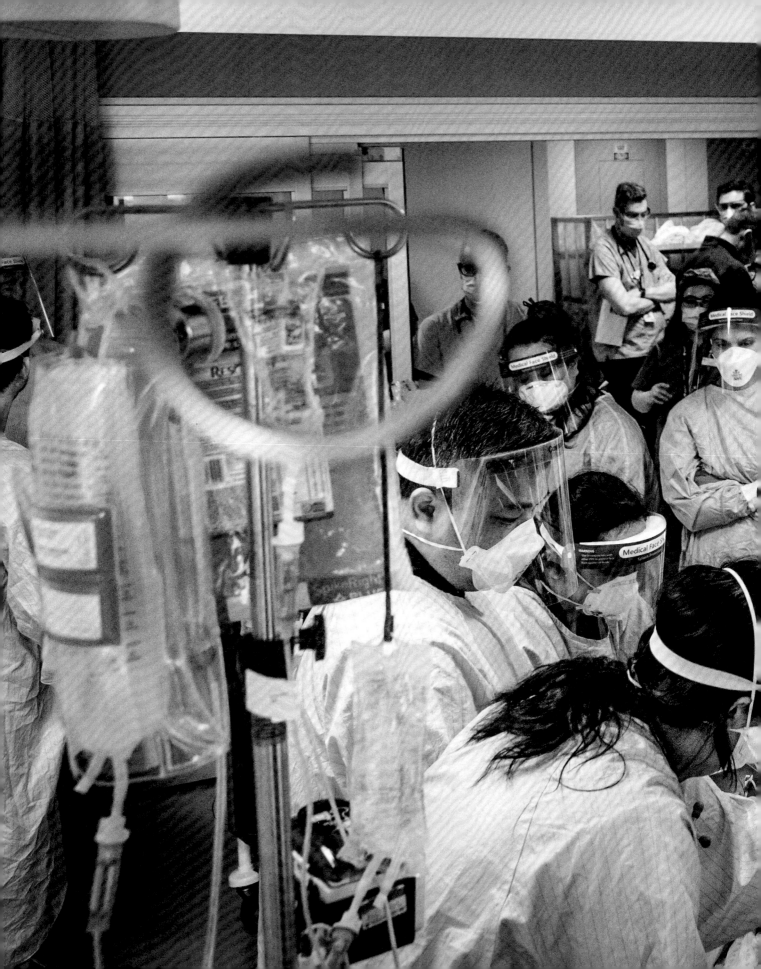

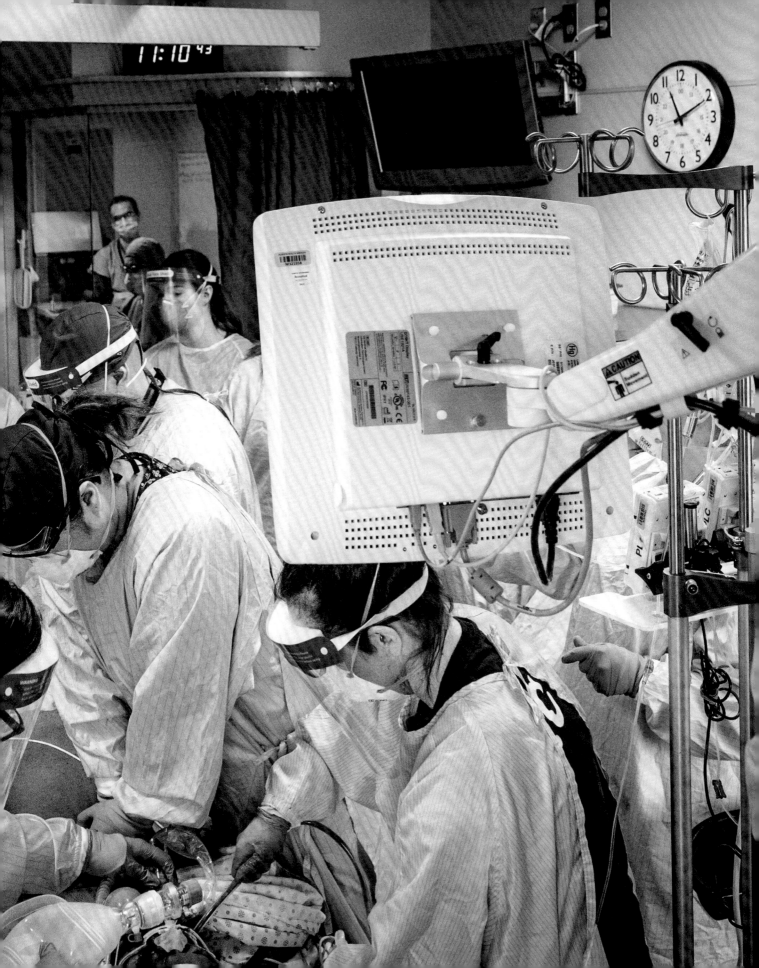

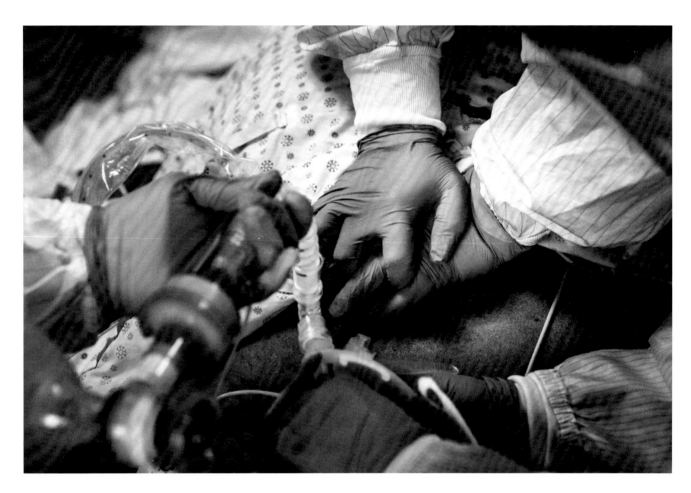

Staff conducts CPR on an intubated patient. As the third wave accelerated, health-care workers described physical and emotional exhaustion. Burnout was no longer hidden; everyone was talking about it. One ICU nursing manager, Patty Infusino, said she was worried about her staff's mental health and wondered if the pandemic would cause people to leave the profession permanently. At more than one ICU in the city, staff confided the deep emotional impact of seeing families say goodbye to loved ones. One family after another. "It is just too much today, but I have no choice," one nurse said, her eyes bright with repressed tears as she cared for two patients in the same room. The night before, she had called a crisis line, feeling desperate. She wasn't alone.

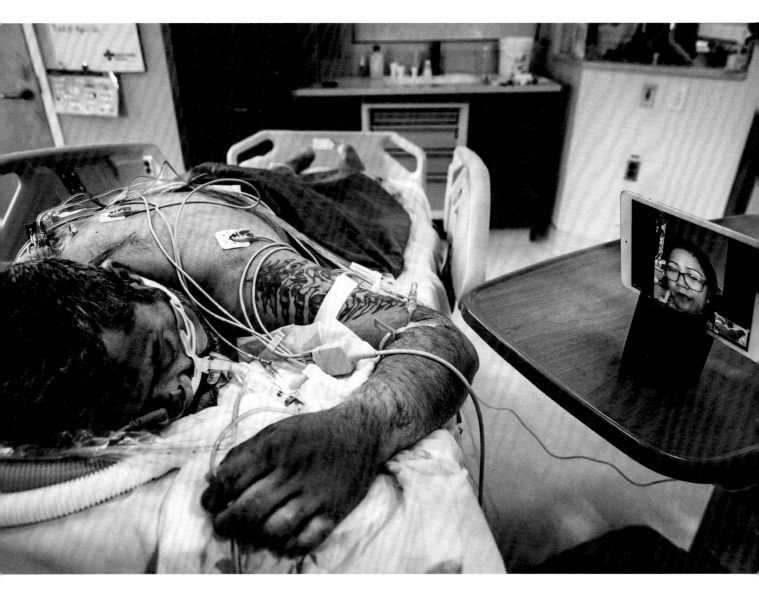

A patient with COVID, intubated, sedated, and in the prone position in the ICU. His wife (right), daughters, sons-in-law, and granddaughter called each afternoon, their tone often light. But his wife couldn't hide her sadness as she pleaded, "Please wake up. It has been too long."

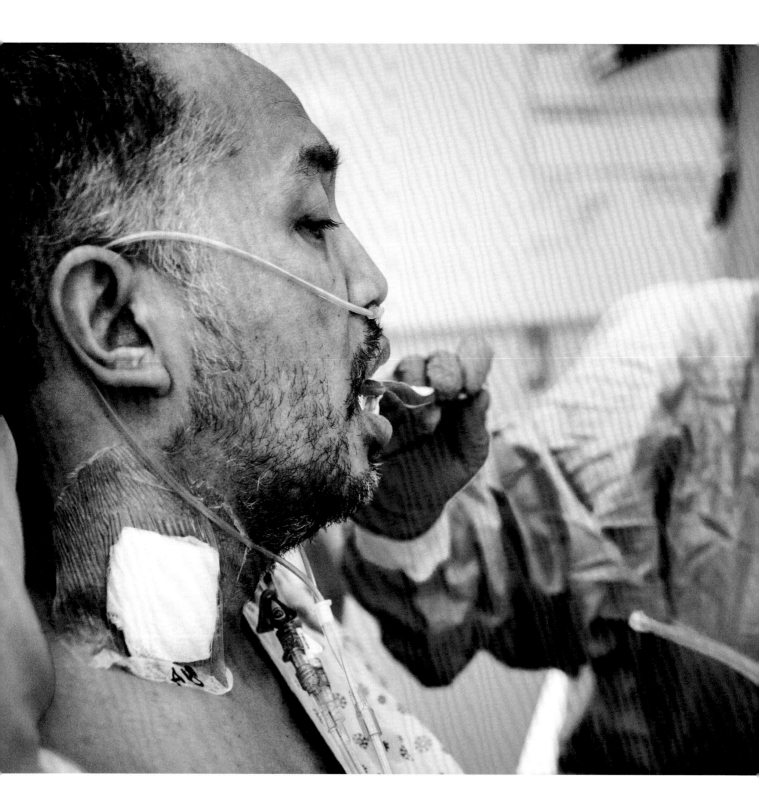

Critical-care nurse Lindsay Mackenzie brushes the teeth of her patient, who had survived his ICU admission and was extubated that morning. Later that day, I saw my friend and colleague Dr. Andrea Boone, who had worked for nine weeks in ICU as well as her shifts in the emergency department. She told me about intubating a man with a young family. He had spoken with a priest, called his wife, and prepared for the worst. Dr. Boone told him the team would look after him, but inside she was devastated, gutted. She guided him safely through the intubation, then went home and cried. She didn't know if he had survived. This took me through my own memories of patients I had cared for over the years. I realized that woven into my experience as an emergency physician was the disquiet of incomplete stories, the discomfort of wondering about recovery and survival.

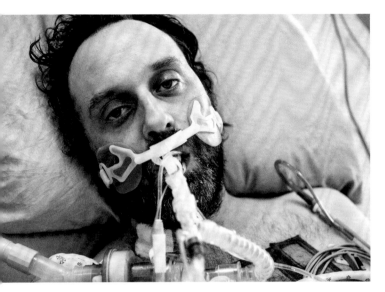 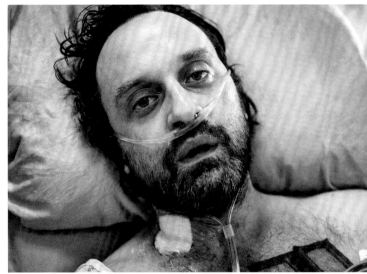

Andrew

(above) Andrew, moments before and then immediately after his extubation. I was outside his room, photographing the ICU staff. He saw me with my camera and waved. I was shocked. He was about to be extubated, which meant he was awake and able to understand, but because of the endotracheal tube he couldn't yet speak. Using pen and paper, he indicated that he'd like to share his story and consented to being photographed. When I re-entered the room with my camera, I noticed the warm light that filtered through the photos of his family and friends, displayed on the ICU window. His partner, Eluvier, had filled out the "get to know you" form with the detail of a master's thesis. In that moment, I realized that I had been photographing like an emergency physician — with the same model of episodic care. One visit, one opportunity to understand Andrew's story wouldn't be enough. He had unknowingly invited me to leave my comfort zone.

(opposite, top to bottom) Andrew's ICU nurse, Tanya Cottrell, holds his hand immediately after extubation. After all that Andrew has endured, his first words to her are "thank you." Andrew later said, "I was so sick by the time I made it to the hospital. My oxygen saturation was sixty per cent. I don't remember my time at the Rockyview at all and I woke up two weeks later at the Foothills." Andrew's mother, Pat, wrote me a note: "The photographic message is so powerful and important for everyone to understand and appreciate that it could be their son, daughter, spouse, cousin, friend, or family member . . . It touches my heart to know someone was there to allay his fears and care for him . . . I am in awe and so grateful for the compassion and expertise of everyone."

Andrew, during one of his long and often lonely days on the COVID ward, still receiving high levels of oxygen while his lungs heal. Andrew remained in hospital for over five weeks, and I visited him often in my role as a photographer. We talked about our careers, families, life before COVID, and how it had changed our lives. Never my patient, he had instead become a friend.

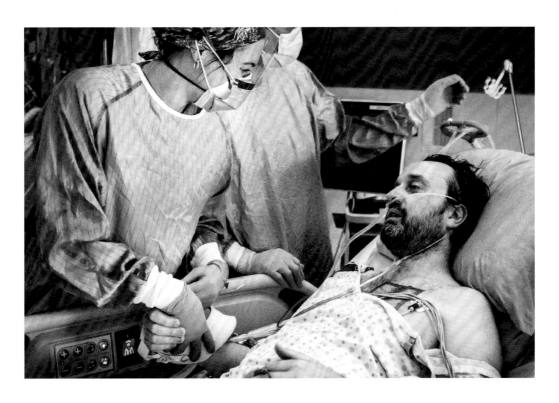

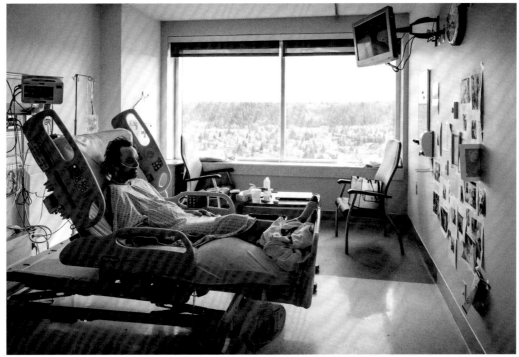

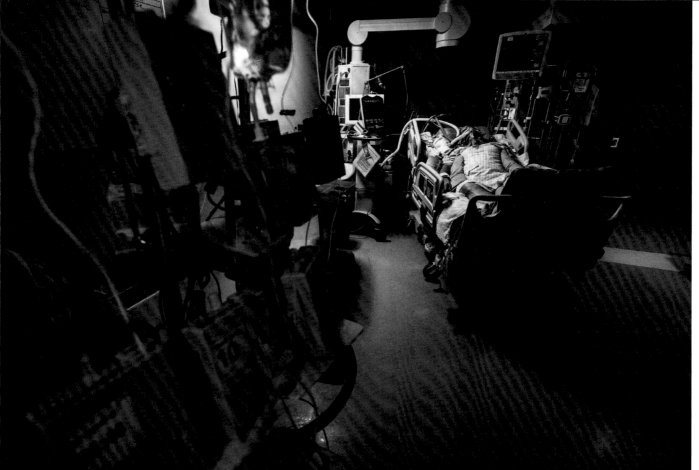

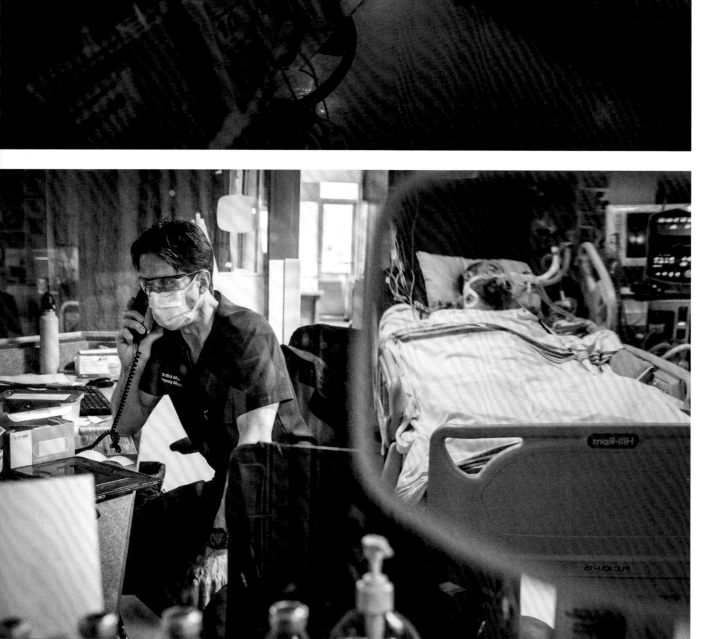

Phil

I met Phil on the day he arrived. He had been sick with COVID for a week, and that morning he was short of breath when walking from the bedroom to the bathroom. His wife, Claire, called their family physician, who immediately directed him to the emergency department. Claire dropped him off at the entrance and waited in the parking lot for updates, not yet aware of how sick Phil was. Over the next few hours, I watched with dread as his oxygen saturation dropped. I had a bad feeling about where Phil was headed.

(opposite) "Please, just bring me out," Phil pleaded with Dr. Rick Morris in the moments before intubation. The care team explained what would happen and gave him time for some onscreen moments with his family. Later, Phil's nurse washed his face, applied lip balm, dimmed the lights, and stayed outside his room to keep a close eye on him.

Phil's reflection in the mirror, in his ICU room, while Dr. Morris speaks with Claire. As the team got to know Claire, they kept her informed about the physiological parameters that were used to mark Phil's progress. Understanding the details, even the technical ones, was important for Claire. It helped give her hope. The anticipated five days in ICU turned into fifteen, and although his improvement was "much slower than expected," things began to turn a corner.

(right) Phil's ICU nurse, Jenelle Bourassa, pushes his wheelchair from the ICU to the COVID ward — the next step in his recovery. His nurses celebrated his departure as they removed the ventilator tubes and lines from his room and packed his belongings. Their faces lit up as they waved goodbye. Moments like these keep the staff going. And Phil's recovery reminded us that others too would survive.

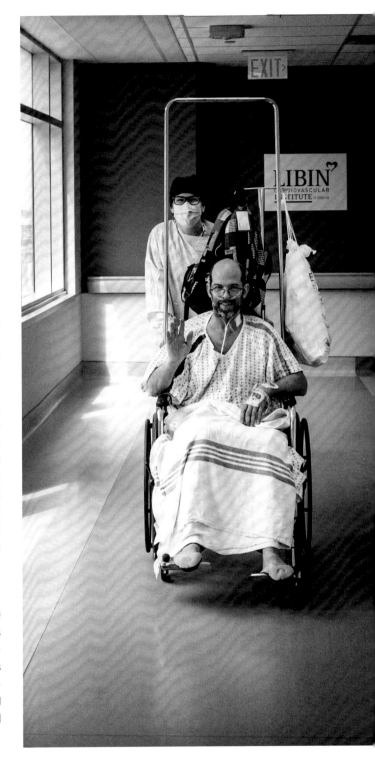

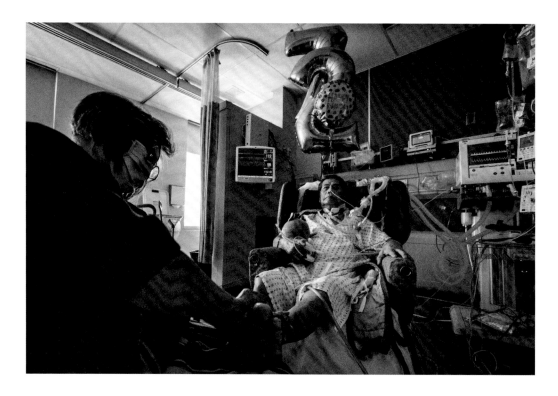

Asher

Asher on his seventy-second birthday with his wife, Elena. His ICU doctor had urged me to meet him: "You should say hello to the patient next door. Maybe you'll get a happy photo for a change." I couldn't tell if he was being sarcastic. It was hard to tell these days. It was the spring of 2021 and we were well into the third wave. Asher had been in the ICU for nearly six weeks, since the end of the second wave. He still bore the wounds of critical illness: a tracheostomy bound him to the ventilator and left him unable to speak, while a nasogastric tube supplied a conduit for liquid foods and medicine. The birthday balloons from his daughter, Resha, were tethered to the chair, just as he was.

(opposite) Elena and Asher holding hands. Asher had nearly succumbed to COVID more than once, and this simple act brought Elena some assurance that he would return home.

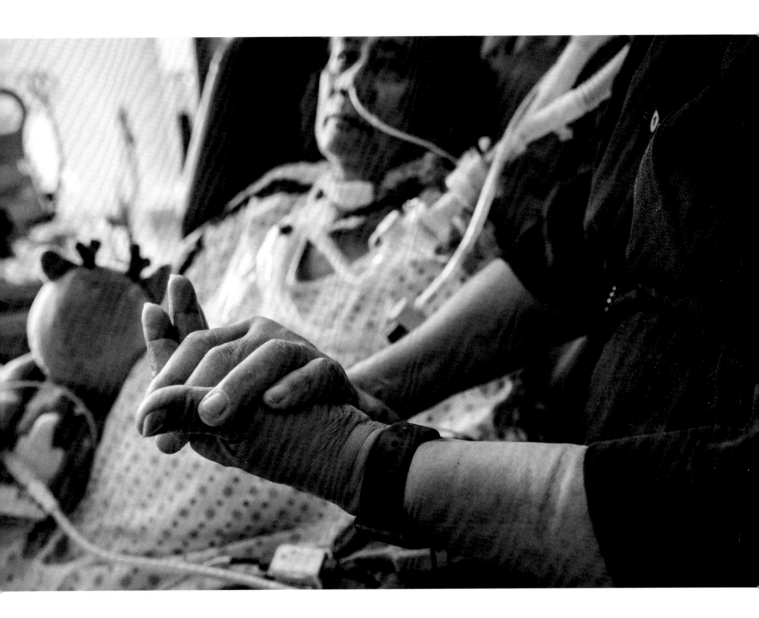

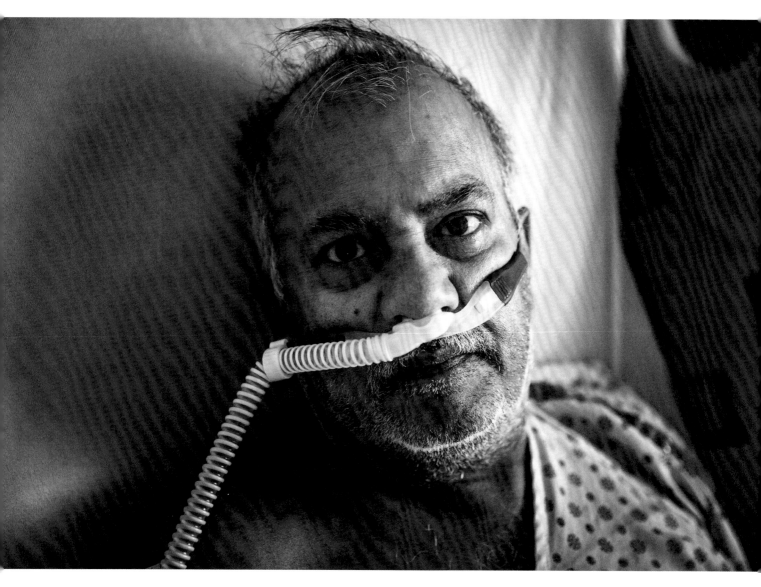

Sam

The day I made this photo, Sam received an email for his vaccination appointment — a few weeks too late. He had been on a medical leave due to an underlying condition, which was stable but put him at high risk. His doctors wanted the leave to continue until he was vaccinated, but he returned to work for three days while waiting for an extension. In those three days, Sam contracted COVID. He showed me the email with a wry look that became sombre a moment later: "I am afraid."

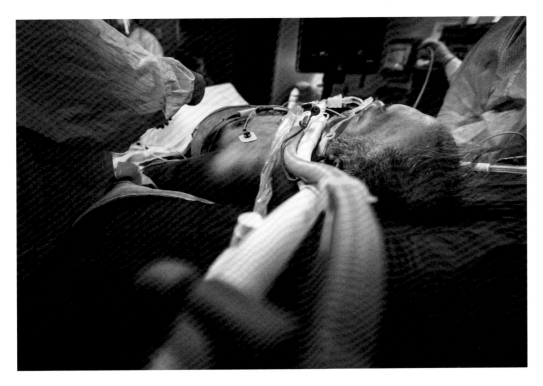

(above) I would think of Sam often. I had not seen him for about a week, and he wasn't in his room on the COVID ward when I stopped by to say hello. I thought "Hurray! Sam has gone home!" and I continued on to the ICU to photograph for the afternoon. I donned my PPE and entered a room where a patient was being moved from the prone to the supine position. My plan was to make a photograph of the incredible effort and teamwork required for this task. But as I stood at the head of the bed, I saw the wispy hair of the gentleman I had come to know. My heart sank. Instead of going home, he'd gotten sicker and had been moved to ICU.

(overleaf) Sam, just after being moved onto his back in the ICU. His condition was precarious. The team waited to see if his vital signs would stabilize, ready to reposition him immediately if necessary. I could see how tenuous the threads were that linked him with this life. Two days later, he succumbed to complications of COVID. I still think of Sam and of his sacrifice — how he put himself at risk in order to serve others as an essential worker. I am devastated for his family in their loss, and I will remember him and honour his story.

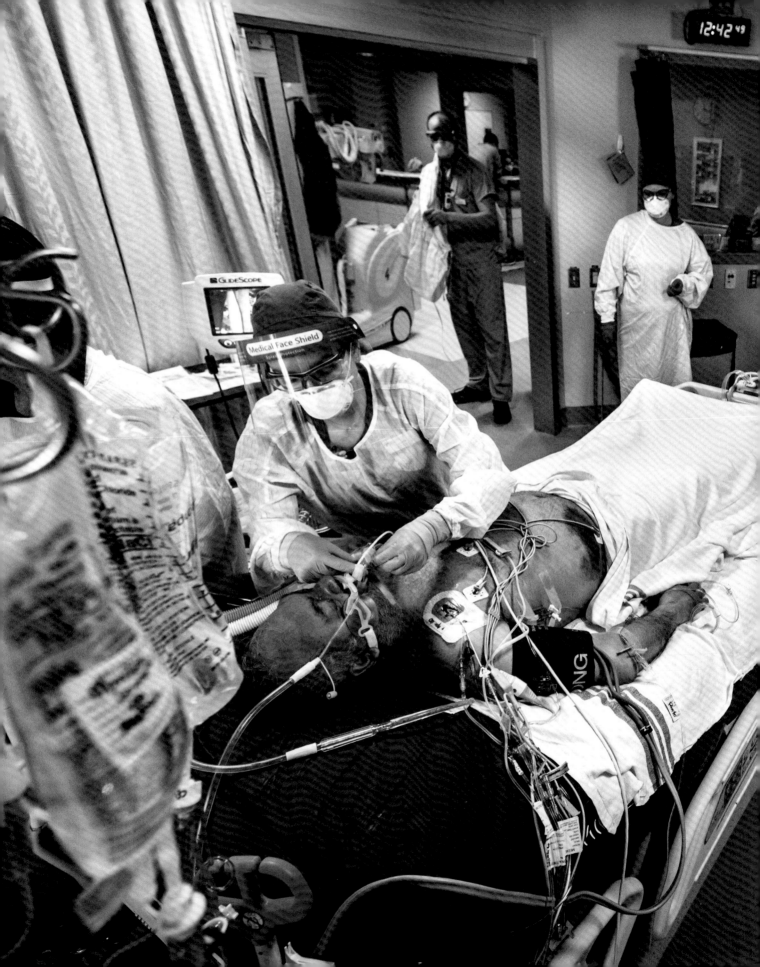

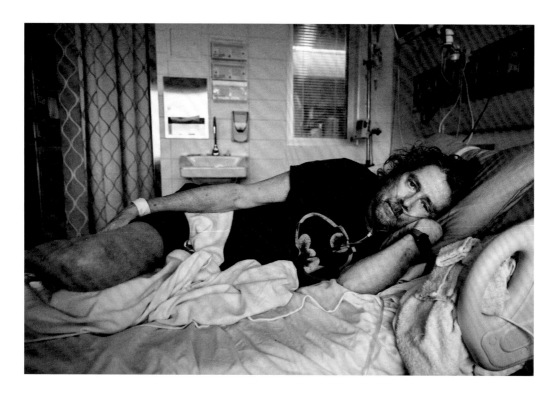

Harvey

(above) Harvey on day forty-eight in hospital. The past year was anything but normal for Harvey, who had developed an immune deficiency after chemotherapy for lymphoma. Many who have had chemo are unable to mount the needed immune response to fight COVID, but in Harvey's case his low response led to a rare occurrence: ongoing positive COVID tests over an extended period. As a result, his family couldn't visit. "I couldn't have imagined a time when cancer would be the least of my worries," he said. Harvey wanted to convey the seriousness of COVID by letting others see the impact on his life. A mountain and road biker, he rode ten thousand kilometres a year prior to lymphoma — and six thousand during chemotherapy. And yet, COVID knocked him down.

(opposite) Nurse practitioner Kevin Huntley greets Harvey. While the rest of Harvey's medical team changed regularly during his six months in hospital, Kevin's presence was constant and allowed for the continuity of care that was needed for Harvey's complex medical condition. He was also a constant source of support and connection when Harvey was isolated from his family.

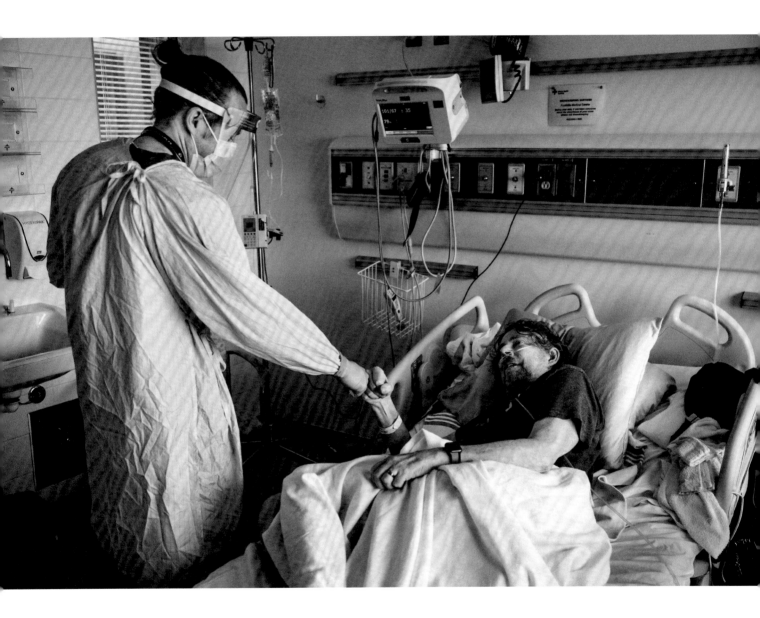

The third wave was not slowing down, and the climbing numbers in Alberta made national headlines as the highest per capita in Canada. By early May, restaurants closed in-person dining, public facilities were shut down, and activities were cancelled. Gatherings of all nature had restrictions. COVID began to feel more political as an anti-lockdown rodeo was held in rural Alberta. Controversy about the nature and degree of public health restrictions dominated the media.

Schools moved to online learning on May 7, but we had taken our kids out two weeks earlier. We knew that if they became ill, we'd both be unable to work and the responsibility for our shifts would fall on colleagues. Our family was tired of the shutdown routine. Kip and I rearranged our shifts so we could alternate being home with the kids. We moved their desks to the kitchen, as we'd done for the first school shutdown. We printed out daily assignments and tried to rally enthusiasm for home-schooling. But in reality, we were done. I didn't check school work for quality or completion. I didn't bake sourdough — the starter was mouldy in the cupboard. I didn't make photographs at home.

But I felt an unrelenting need to be photographing in the hospital. I'd felt flashes of this insatiable pull earlier in the pandemic, but now it drove me to photograph in all of my spare time. I would often return after long days of work in the emergency department. I would gather my equipment and head back out the door after dinner, rather than reading stories with the kids at bedtime. I tried to make up for it with focused periods of time together, desperately wanting to believe that someday they would understand why I made this choice. Kip selflessly carried the weight of all of the tasks at home, in full support of my work.

I wanted to make a difference. If images were worth a thousand words, could they motivate people to get vaccinated and follow public health guidelines? Could they remind us about the importance of our own actions and how they affect others? And as I posted photos on the Instagram account that I had created for the project, I started to hear about their impact. Patients who had experienced memory gaps during their care expressed gratitude for the chance to see and

understand what they'd been through; families felt comfort, seeing the care their loved ones had received; and staff members such as Korey Fung, a clinical dietitian, found inspiration:

Yesterday I found myself looking through your page as I often do on Sunday before heading back into the fray on Monday. I find your photos a great reminder of who we are as clinicians and why we answer the call daily to help people in their time of need. I was absolutely moved by your latest photo because I have been privileged to be involved in the care of that gentleman. Your page has always felt very personal to me because you provide a voice for all health-care workers. With your latest photo I felt that much more honoured to be in the field and that I was part of his story.

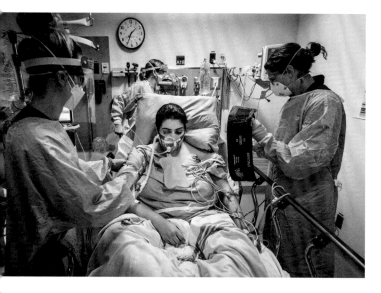

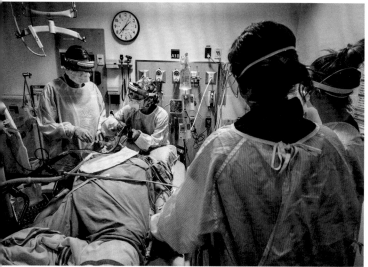

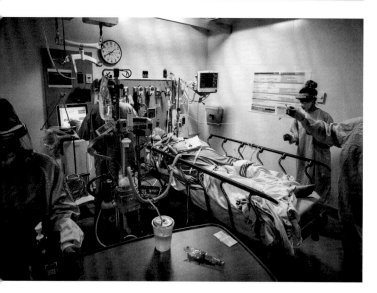

Sabbohi

(left) Sabbohi, twenty-nine, in the emergency department. Sabbohi described the moment when she realized she might not survive. While the team moved around her, gathering the equipment and medications for her intubation, she sat, eyes closed, motionless except for her rapid breathing, saying her final rites from the Qur'an and pleading with God to give her another chance. After being intubated at one hospital, where the last ICU bed had gone to another intubated COVID patient just thirty minutes before, she was transferred to another hospital. She spent just under two weeks intubated while her husband, Mohsin, provided daily updates to their large extended family in Canada, the UK, and Pakistan. Mohsin rarely slept during Sabbohi's days in the ICU when her survival was uncertain. He would hold her hand, talk to her, and play recordings from the Qur'an.

(opposite) When Mohsin arrived at the hospital to take Sabbohi home, he brought clean clothes but forgot to bring her shoes. She teased him about forgetting such a critical and stylish part of her going-home outfit. Laughing, she wore his shoes, many sizes too big, out to the car. On the way home, they stopped at her mother's house to wave from a distance and pick up kabobs that were waiting on the doorstep — her favourite home-cooked food.

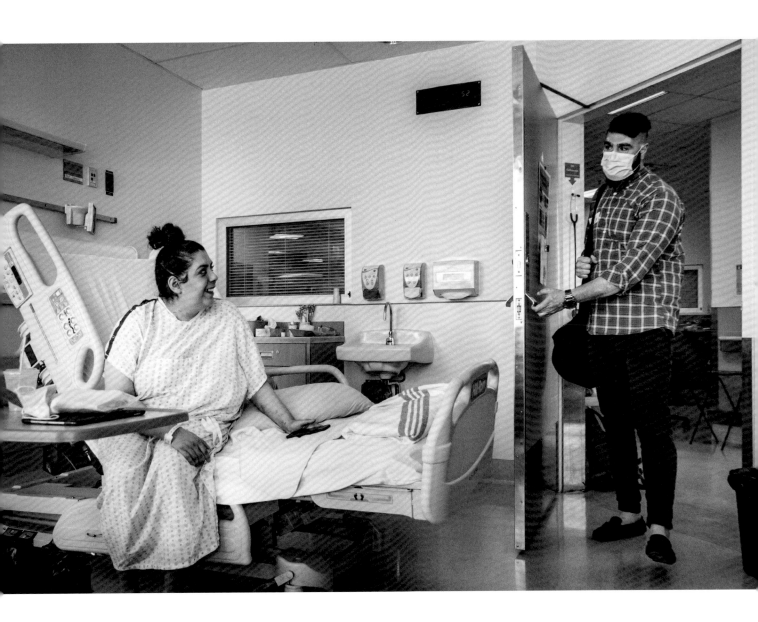

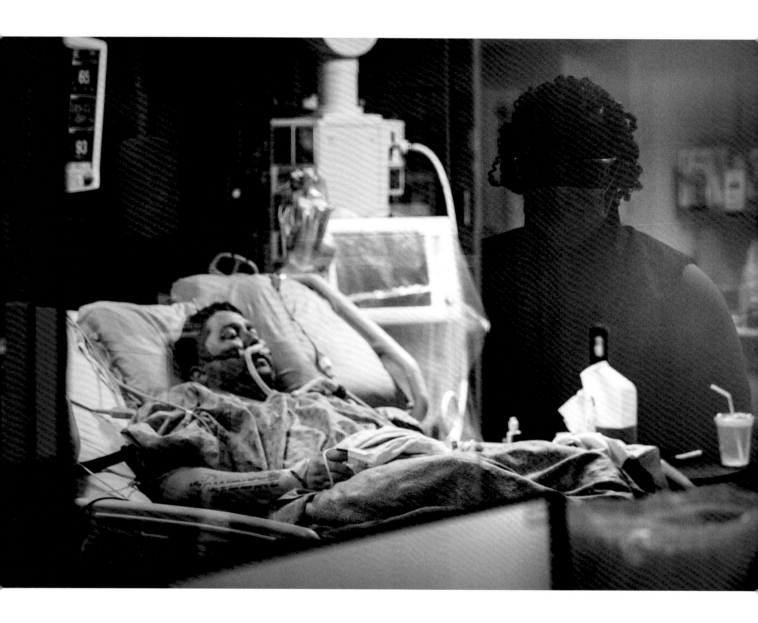

Rob

(opposite) Rob, on the day he before he was intubated, carefully watched by Juliette Johnson, a nurse clinician in the ICU. Rob became infected with COVID after coming into contact with someone who was breaking quarantine rules. Rob and I met on his first day in the ICU. Our conversation was brief — if he answered with more than a few words, his oxygen saturation would decline. He told me about his work as a scaffolding supervisor; his lovely wife, Misty; their three daughters; and the discomfort he was feeling from multiple IVs and tubes and the high-flow oxygen drying his nose.

(right) Rob's first steps after eleven days on a ventilator. His recovery was marked by determination and a sense of humour, but also by loss. His grandmother died of COVID while he was intubated. He learned of her death shortly after waking up and knew that he had to be physically and mentally strong to help his family. Health-care workers always left his room smiling — his positivity was contagious and a gift to those who met him during the long third wave. We spoke on the phone months after Rob returned home. "I show your images all the time when I talk to people about getting the vaccine," he told me. "It makes it much more real when they see a picture of me intubated. It works."

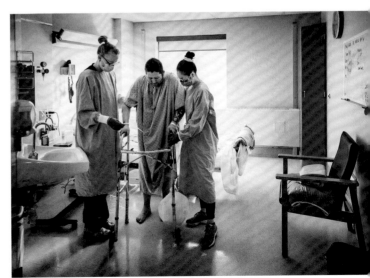

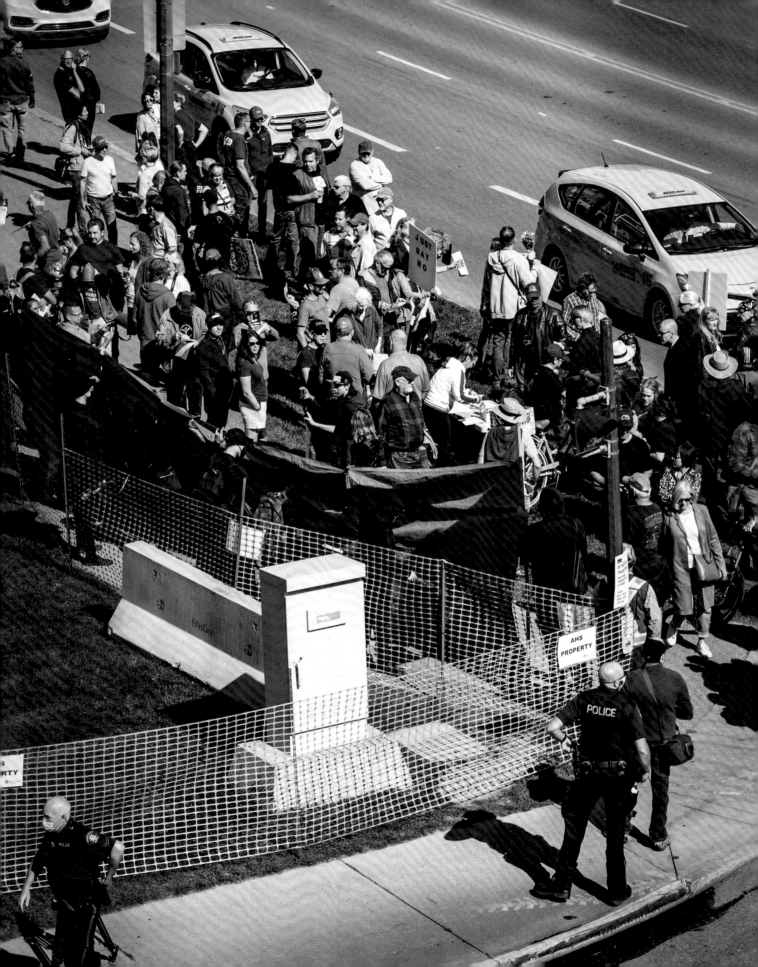

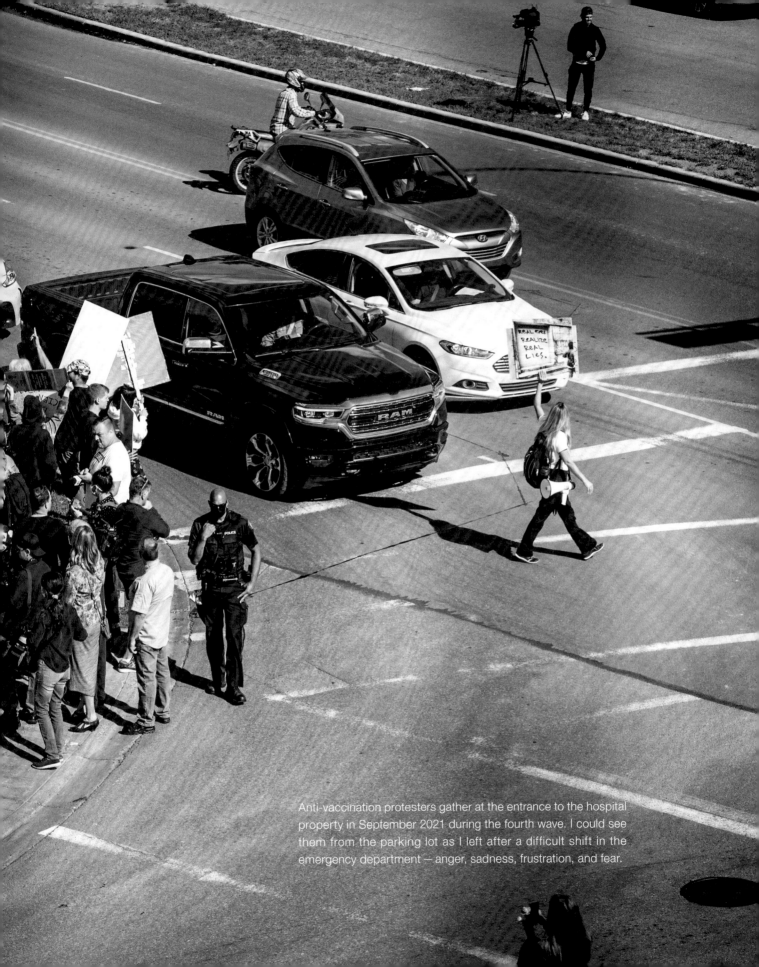

Anti-vaccination protesters gather at the entrance to the hospital property in September 2021 during the fourth wave. I could see them from the parking lot as I left after a difficult shift in the emergency department — anger, sadness, frustration, and fear.

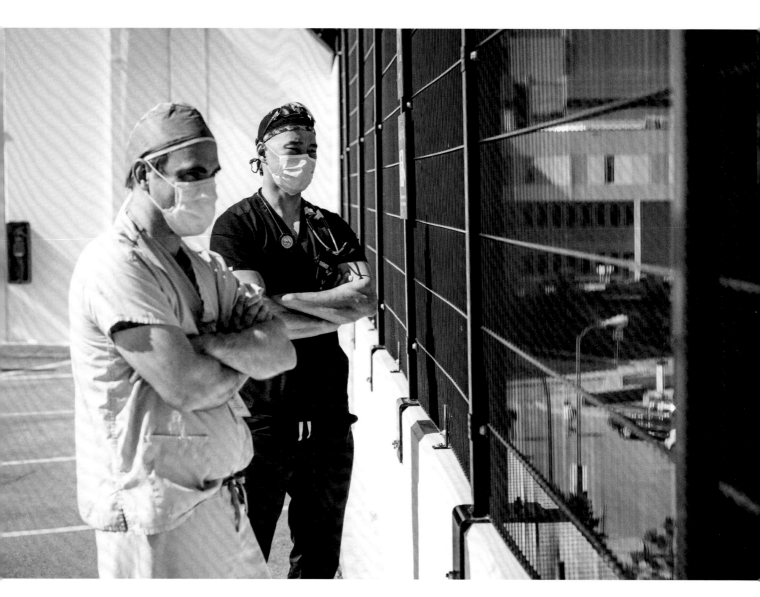

Dr. David Jungen (left) and Dr. Dave Choi (right) look on as protesters gather at the entranceway to hospital property. In a minute they'll go back inside and keep caring for patients, many of whom held the same belief about vaccination as the protesters below.

SIX
The Fourth Wave
Not the Best Summer Ever

"It doesn't matter who you are, what you do, or what your decisions were before this. We will take care of you the same every time."
— Dr. Rick Morris, emergency physician

"COVID is taking you away from us again, Mom," said Hannah, with sadness in her voice. She was right. Kip and I were greatly affected by the resurgence in Alberta during late summer 2021. We felt abandoned in our worries about the developing fourth wave, as citizens were encouraged to return to pre-pandemic lifestyles. Premier Kenney promised Albertans the "best summer ever." Mask mandates were lifted, the Calgary Stampede went ahead, and the premier went on vacation. Scientists and physicians with dissenting voices were called fear mongers. We were left alone to face the increasing number of COVID patients. This, coupled with the politicization of COVID vaccination and protests outside hospitals, led to a heaviness that we carried into all aspects of our lives. Kip and I were short with each other, struggled to find the normal pleasures in day-to-day life, and were reprieved only when we hiked in the mountains.

As time marched on, the disturbing predictions about the number of people who would suffer and die were met. Alberta's rates of active infection were more than four times the national average. Our hospitalization and ICU numbers reached record heights, and we required assistance from the Canadian Armed Forces, the Canadian Red Cross, and health-care workers from other provinces.

We prepared for the worst-case scenario: the implementation of "critical triage," a process that could be used to determine which patients were eligible for ICU care, based on a range of factors related to their probability of survival. This was

ready to be initiated if the province reached the point where it was no longer able to provide critical care for every patient who required it. Critical triage was avoided—narrowly—but having to prepare for it was devastating, a situation I didn't ever expect to encounter as a physician in Canada. I couldn't imagine sitting at the bedside with a patient under my care, or with their family members, and telling them there wasn't a ventilator or ICU space available to save their life.

(right) Two ICU nurses working together — ICU rooms were once again holding two patients instead of one because of record numbers. The regular staff was again supported clinically by physicians, nurses, respiratory therapists, and pharmacists redeployed from other areas of the hospital.

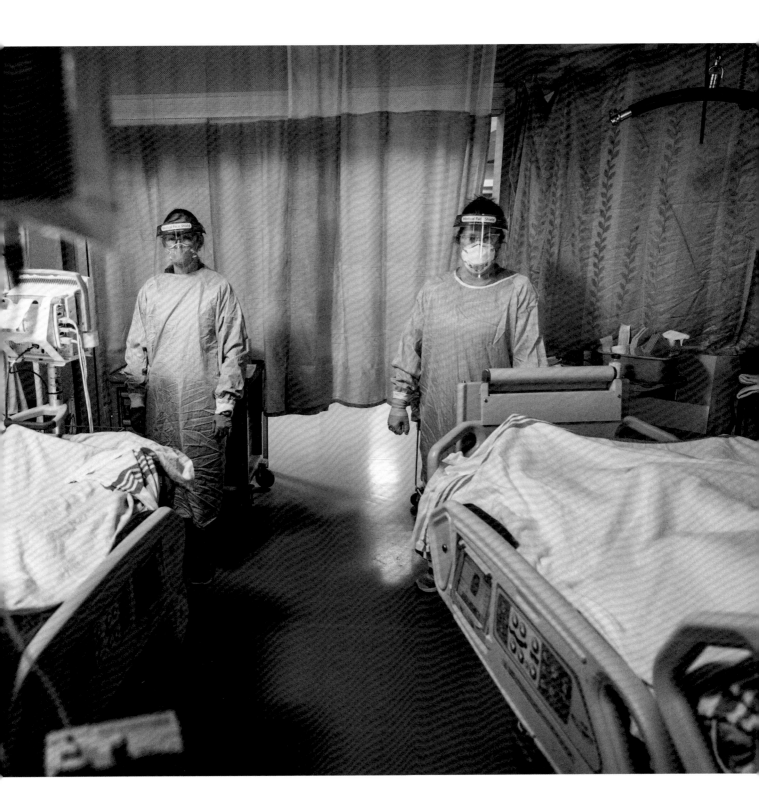

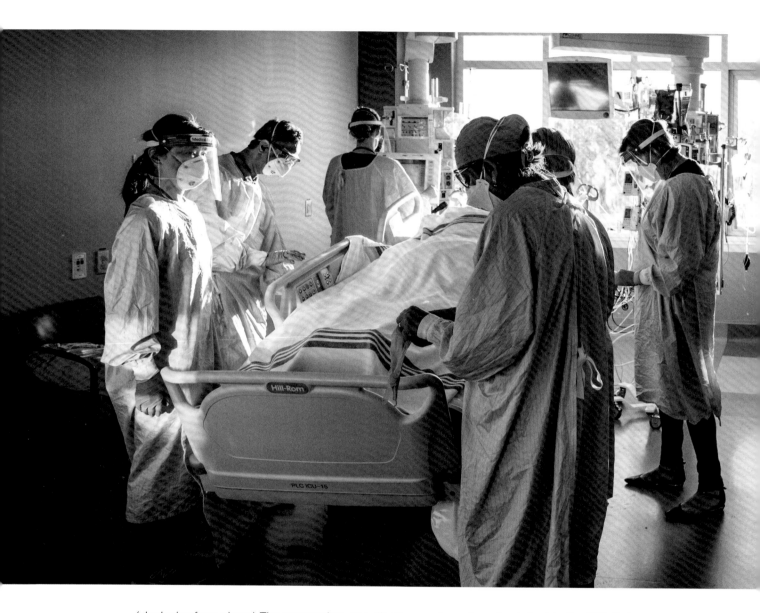

(clockwise from above) The preparation, coordination, and proning of a patient in the ICU. Twice daily, the team, composed of site leadership and staff from all over the hospital, would move from room to room, donning and doffing PPE, moving patients onto their stomach or back. The Peter Lougheed Centre developed this volunteer program to assist the ICU with the time-consuming, labour-intensive process of proning — sometimes twelve patients per day.

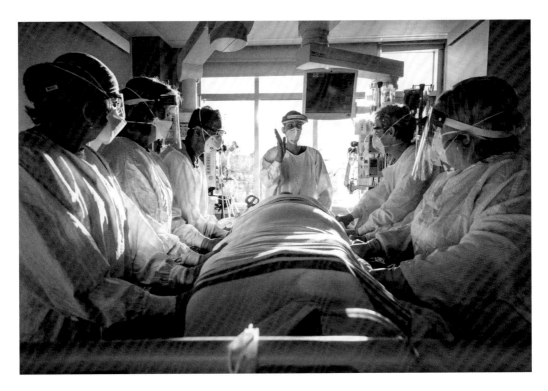

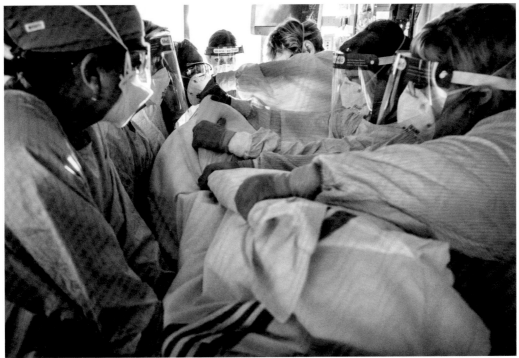

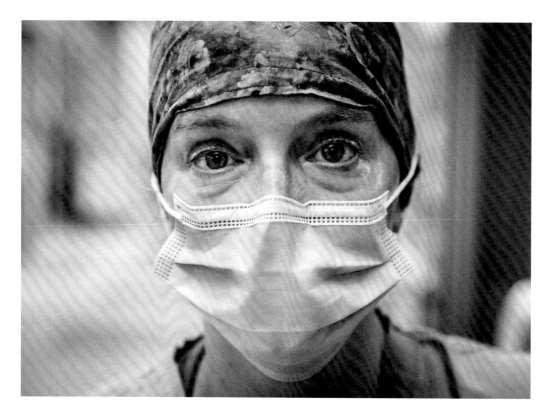

Sheri McKay has worked as an ICU nurse for nearly thirty years. Like so many others in health care, she was exhausted — not necessarily because of the work but because of the profound frustration over vaccination resistance. Sheri lamented that everyone will be affected by COVID — either with the virus itself or by the impact on the health system. She said she would continue as a nurse but could understand why others were leaving.

The psychological response that many health-care workers have experienced during the pandemic is called "moral injury" — a term for the effects of moral conflict during times of extreme resource limitation or threats to one's safety. Repeated moral injury can lead to devastating mental-health effects including burnout, post-traumatic stress disorder (PTSD), and addiction. Medical and nursing associations have expressed concern about their members and are preparing for an exodus from the profession.

+

During the fourth wave, more than eighty per cent of patients hospitalized with COVID in Calgary were unvaccinated. Most patients trusted us to provide evidence-based medical care for everything else — but now, for some people, not COVID. I was too often treated with suspicion and disdain when I asked about vaccination status. My colleagues and I had repeated discussions with families and patients who denied the existence or severity of COVID, sometimes right up to the point of intubation. Others demanded treatment based on their own research about anti-parasitic medications. It was time-consuming, exhausting, and demoralizing.

I was surprised and dismayed by the number of people who had been confused by misinformation about the vaccines or were scared about side effects. I saw patients begging for a vaccine before their intubation, as they came to the horrible realization that they'd been lied to. I met unvaccinated family members who had infected their vaccinated but compromised elderly parents. And I saw their heartache and regret. It was a preventable, and sadly frequent, scene.

Nearly twenty per cent of patients admitted for COVID *were* vaccinated — people of all ages, most of them with underlying medical problems such as cancer, organ transplant, or multiple sclerosis, unable to mount the normal immune response required for protection. They ended up in hospital even if they had done everything right to avoid COVID. It was heart-wrenching to hear their stories, to watch them suffer and die.

At times I identified with the sentiment of one colleague who described her "intense burning fury" with those who had "prematurely lifted COVID restrictions, and those who initiated and spread misinformation about the virus and vaccine." But anger is exhausting, and I needed to preserve my energy to take care of my patients, my family, and myself.

With the roller coaster of emotions I felt every day as a physician, photographing people again provided the clarity and space I needed. Vaccinated or not, everyone had a story. Everyone was afraid.

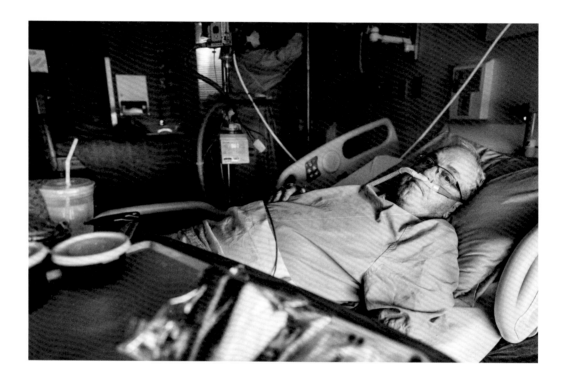

Jim

(above) Jim, on the day when he learned that his doctors didn't think he would survive. Jim's medical conditions left him prone to serious COVID infection despite being vaccinated. Although he had worsening COVID pneumonia, he refused to concede — he told me he would be going home to his new job, as planned.

(opposite) Due to his poor prognosis during the time he was still infectious and receiving ongoing high-flow oxygen, window visits were the only option for Jim and Judy. She would often stay for hours, sometimes talking to Jim on the speaker phone outside his isolation room — sometimes sitting in silence, just being present. Jim's family brought his favourite foods, which staff in full PPE would carry in to him. Every time I came to the hospital to talk to Judy, or texted her to see how Jim was doing, I waited apprehensively for news. But Jim was right. Weeks later, against all odds, he went home on oxygen and began the long recovery process. The day after he left, as I sat outside in the sunshine and listened to leaves rustling in the trees, I felt so grateful for the hope that Jim had shared with me. I smiled at the thought of him enjoying the same warm sun.

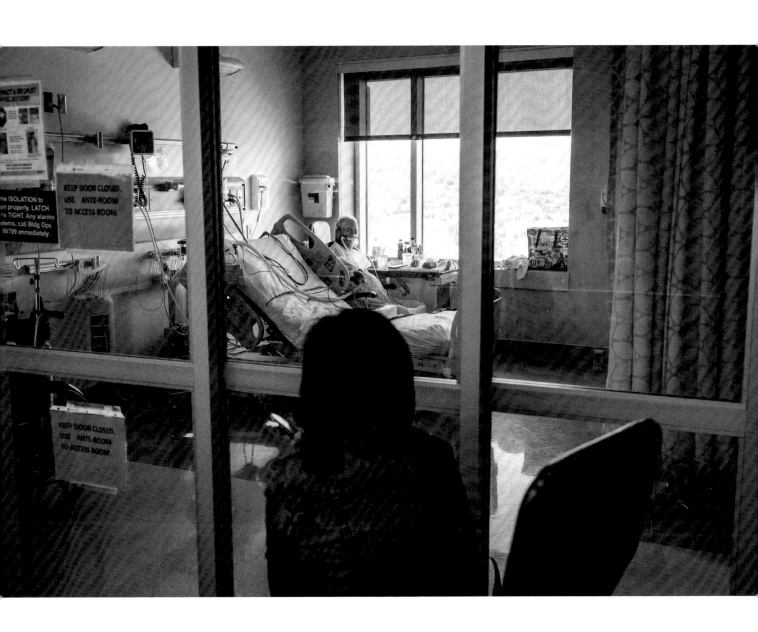

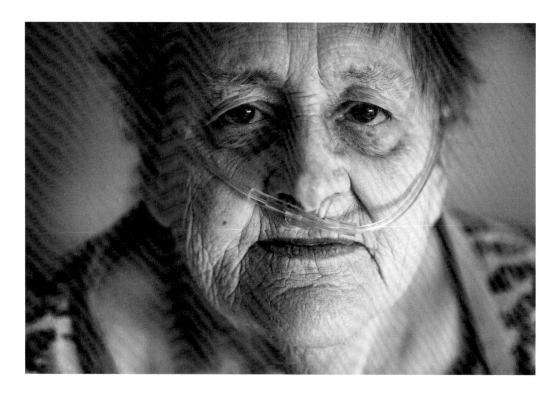

Heather

(above) Heather, a vaccinated patient with COVID, says she chooses never to have a grumpy day in her life and believes that with a positive outlook and determination she will overcome any challenge she faces.

(opposite) Heather doing her daily exercises to prevent blood clots (DVTs) in her legs. I could hear laughter coming from the room, and when her nurse walked out moments later he told me I just had to meet his patient. Heather showed me a handout about DVTs, shook her head, and said that her legs would never look like that. She proceeded to show me leg circles, leg lifts, and flexibility moves that made her look like a twenty-year-old. We talked and laughed together for over an hour.

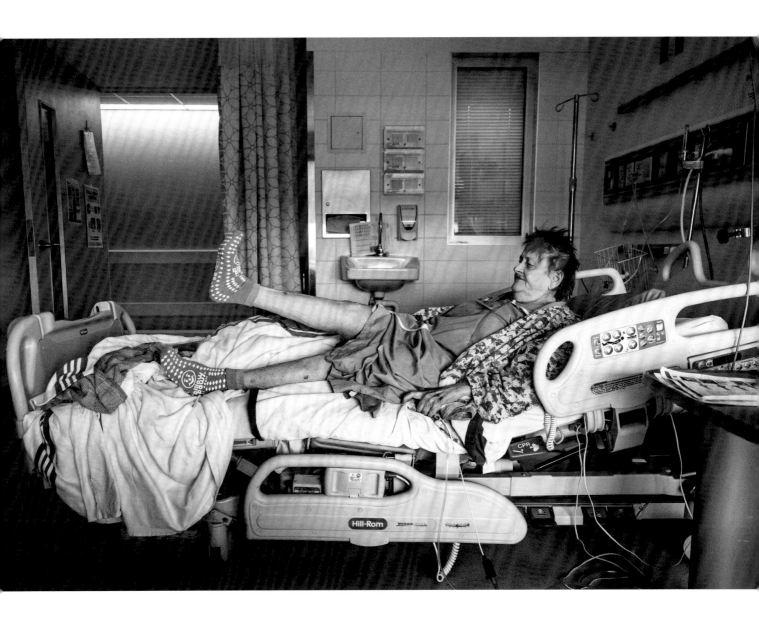

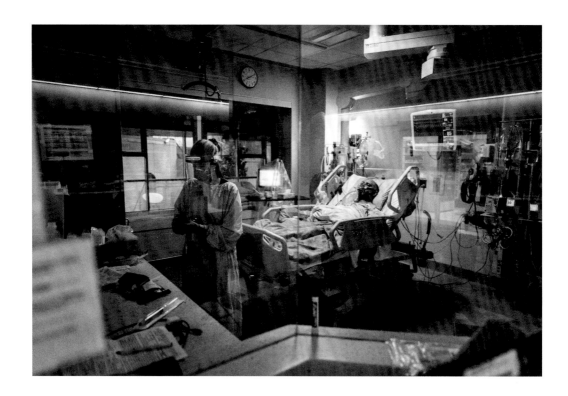

Post-transplant patient with COVID

(above) A patient (who has chosen to remain anonymous) quietly struggles to breathe while the team prepares for his intubation. Not yet vaccinated, he had been waiting to speak with his specialist about the risk of any dangerous side effects due to his history of transplant. He told me he was thinking about his family, especially his mom, and worrying about how his illness — and maybe death — would cause her suffering. It was her birthday, a day when he wanted her to celebrate, not mourn. As with other patients I've spoken to before intubation, the moments ticked by excruciatingly slowly; they are acutely aware of their mortality, praying for survival, and saying what might be goodbye.

(opposite) As the patient falls asleep from the medications for intubation, critical-care fellow Dr. Brandon Hisey (right) and respiratory therapist Ahshi Dost lean in. "We will take care of you," Dr. Hisey reassures him.

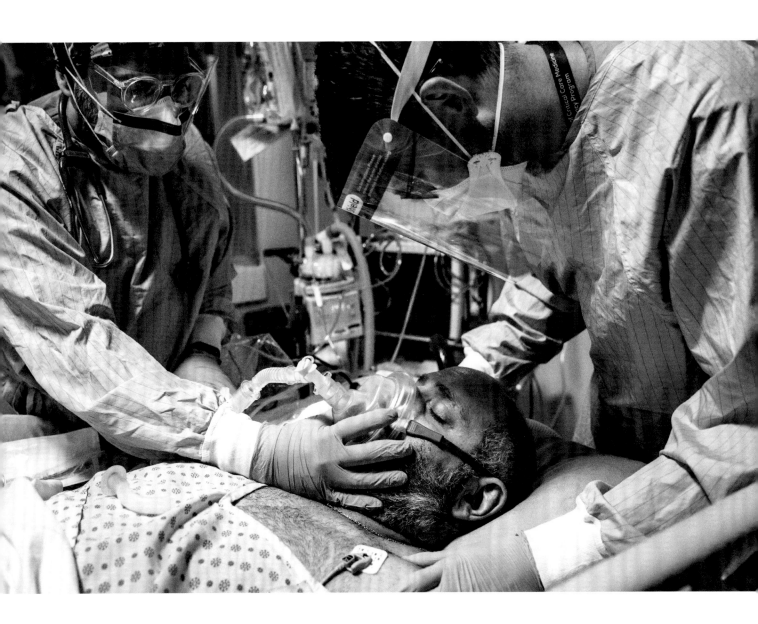

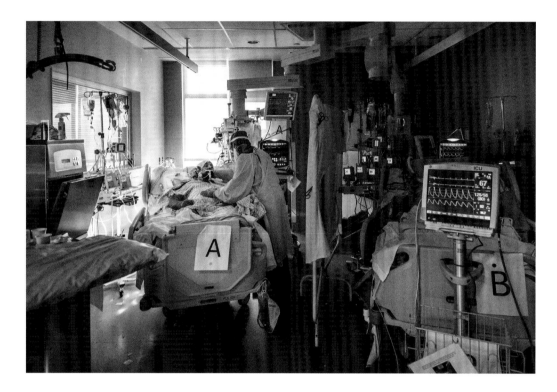

Bernie

(above) Bernie, being treated in a shared ICU room. He later explained that he wasn't against vaccines but had put off getting one, a decision he regretted. He spent eleven days intubated "in a very dark place," thinking it wasn't worth the fight, living through hallucinations and the discomfort of the tubes and lines. His nurse, to whom he says he owes his life, didn't give up on him, showing him "tough love," insisting that it wasn't okay to quit.

(opposite) With tears in his eyes, Bernie waits to see if his oxygen saturation is good enough to try walking without oxygen — something he desperately wants to do, with his daughter's wedding just days away. He succeeded and proudly walked her down the aisle.

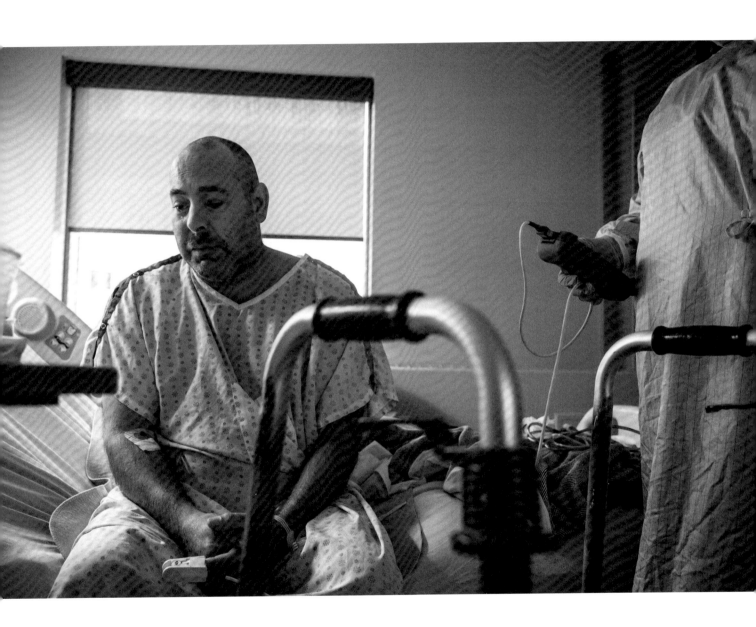

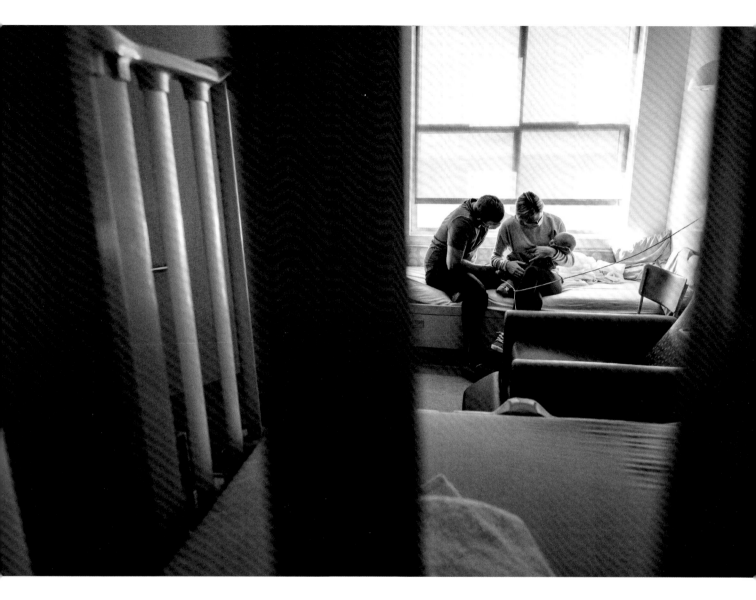

Nash

Nash, snuggling with his parents in hospital. Too young for vaccination at nine months, he contracted COVID. We saw an increase in pediatric cases and admissions to the Alberta Children's Hospital during the fourth wave, including children admitted to the ICU. Watching infants, children, and teens suffer was heartbreaking as a parent and a physician. I desperately wanted everyone to recognize the impact on children.

+

In time, the protests in front of hospitals ceased, but the divide between the vaccinated and unvaccinated did not. My hopes about the positive changes that COVID might leave us with — community togetherness, acts of service for those in need — had all but disappeared. The pandemic even divided our medical community, with some health-care workers refusing vaccination and creating more confusion about safe, evidence-based choices. This was a difficult, revealing, and divisive time in our collective history.

During these exceptionally hard times, however, good-hearted Calgarians continued to support us with a new influx of cards, thank-you notes, and gift cards for hospital coffee shops. A local catering company delivered Thanksgiving turkey dinner to ICUs across the city, and bakeries sent us individually wrapped gourmet cookies for snacks. As I unwrapped my cookie, alone in a tiny alcove office in the emergency department, and briefly removed my mask, the words "comfort food" took on a whole new meaning.

This wave felt more trying, more emotional, more exhausting. As I drove to work each day, I began making a deliberate choice to focus not on the politics, the unfairness, and the sadness but instead on the privilege of caring for others. When the numbers began to decline, there was a sense of relief, but I didn't celebrate. I no longer believed that COVID would ever be over.

SEVEN
Pandemic Insight
COVID's Long Shadow

It's not just the physical effects of not getting surgery, which are substantial and impact what we can do, but it has a huge emotional impact on our lives.

—Dale, a patient waiting for elective surgery

While this project focuses on those directly impacted by COVID, the broader effects of the pandemic have become increasingly apparent as we progress through each wave. At the onset, the delivery of health care was disrupted, with many general practice and specialty outpatient clinics closed to in-person appointments and surgeries delayed. Pediatric and adult emergency departments had fluctuating patient volumes—sometimes eerily empty when people were afraid to come to the hospital and, later, sometimes cripplingly busy and plagued with "bed block," with so many people waiting for hospital rooms to free up.

It will likely take years to recover from how the pandemic has impacted the delivery of health care, but the determination to provide excellent care, innovation, and kindness endures. And it will be needed in the months and years to come.

(opposite) An empty operating room in September 2021 — one of many. Two months later, AHS reported that fifteen thousand surgeries were delayed or cancelled during the fourth wave of COVID in Alberta, bringing the total to forty-five thousand for the first four waves.

Emergency Departments

With many people afraid to seek medical care when they normally would have during parts of the pandemic, emergency physicians often saw late presentation of disease. For example, we saw patients whose cancer had spread to a more advanced stage by the time of diagnosis or those whose appendices had burst, causing sepsis. We encountered rarely seen complications of disease, such as ruptured walls of the heart due to heart attacks that people hadn't recognized or come to the hospital to have assessed. Dr. Eddy Lang, department head of emergency medicine in the Calgary zone, went to the media to encourage people not to stay away for fear of acquiring COVID at the hospital. He said emergency departments were open, as always. "They are safe and ready to receive patients," he urged.

Surgical Care

With each wave of COVID, the number of delayed or cancelled surgeries increased. Life-saving emergent surgeries, urgent surgeries, and prioritized cancer surgeries continued to be performed, but non-urgent surgeries that required a hospital stay and those that were considered elective were put on hold. As AHS explained, these holds were necessary to "ensure . . . the ICU capacity for those who need critical, intensive care" and to "support redeployment of front-line staff and resources to the greatest area of need."

However, the terms *non-urgent* and *elective* can feel misleading when considering the impact on people's lives. With sadness etched into his face, one orthopedic surgeon described the condition of his patients who were waiting for hip or knee replacements. Now relegated to wheelchairs, or having falls due to the opiate medications they were taking to control their pain, they continued to wait for a surgical date. Their condition wasn't life threatening, but the ongoing cost of waiting was evident. Dale, a retired police officer, said he'd been waiting more than a year for hernia surgery, while his wife, Tammy, waited for knee surgery. He understood that these were considered "elective," but the uncertainty was still hard, their lives disrupted. The toll was evident in his voice, his hands knotted together in his lap.

It has become more common to meet such people in the emergency department, suffering due to delayed surgeries: a young father, who would normally have received curative cancer surgery the next day, but who left without a surgical date; the mother of an ICU nurse, whose Whipple procedure—a complex abdominal surgery, due to complications of her prior cancer—was cancelled; a patient who needed an aortic valve replacement and whose condition had deteriorated during the wait for surgery, now with heart failure and an unstable dysrhythmia.

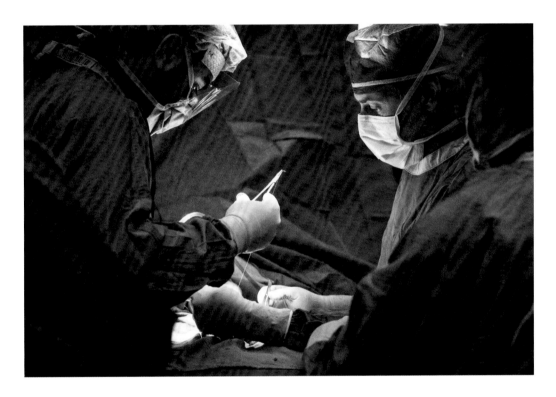

Dr. Neil White (right) and his surgical fellow, Dr. Patrick Tohme (left), perform a wrist surgery that has been delayed for more than six weeks and now requires a novel approach to restore function. Their operating suite was one of only two in use on this day.

Mental Health

The COVID pandemic has been mirrored by a mental-health crisis, often referred to as the shadow pandemic. Mental-health units saw a skyrocketing number of patients, and those who had COVID or were considered a close contact required isolation. This was not an easy task. "Due to the gregarious nature of mental-health units coupled often with poor attention to hygiene or disorganized behaviour, there is a high risk of spread of illness," said Dr. Mike Szymczakowski. "Multiple mental-health units had outbreaks of COVID where a significant number of staff and patients contracted the illness." Masks, required for patient and staff safety, were a double-edged sword, as Dr. David Pocock explained: "Being able to see a person's face—not just behind a mask—is important…for us to be able to do our job well and for our patients to see a human being offering support and treatment, with facial expression, emotions, and empathy."

Dr. Rita Watterson described the general mental-health situation with a poignant analogy: "At baseline, the system isn't perfect but it's able to do the job. It's like getting two kids all cleaned up in the bath. In COVID times it feels like there are ten children. Not only that, but they spend the whole day outside and they are really dirty. Then you look at your tub. It's started to crack a bit and now it's leaking. You throw in the ten kids, try really hard to get them clean, but inevitably you miss someone's ear; there is mud on the walls, and water is dripping out. And now you are exhausted. The next day the kids are all in the backyard again and you have to muster up the courage to do it all again."

The effect of the pandemic on pediatric mental health, in particular, became a major health crisis in itself. Alberta Children's Hospital saw a twenty per cent increase in mental-health presentations to its emergency department, and a forty-two per cent increase in the number of admissions—reflecting the severity of these young patients' illness. At times, pediatric patients with mental-health issues occupied entire sections of the emergency department, awaiting assessment or waiting for a room on the psychiatry unit.

Dr. Mark Bromley, a pediatric and adult emergency physician, shared his experience during the middle of the third wave: "I haven't admitted a [child] yet for COVID, but every shift I admit at least one child with suicidal ideation and see two or three others who likely should be admitted, but we don't have the resources. I support all of the [public health] restrictions but acknowledge that it comes at a cost to some people's mental health."

As in many other areas of the hospital, burnout of mental-health staff was prevalent due to the increased suffering and limited resources.

(above) Dr. Jessica Sparling assesses an agitated psychiatric patient in the emergency department. Psychiatrists and mental-health teams saw record numbers of patients presenting with schizophrenia, bipolar disorder, depression, anxiety, and obsessive-compulsive disorders. Loss of in-person community supports due to COVID-related closures and an exacerbation of substance use coupled with financial stressors, poverty, and social isolation increased distress.

(overleaf) A young man in the emergency department. He spent over two hundred hours here waiting for a bed on the psychiatry unit. COVID-related isolation procedures, on top of the already-stretched capacity of mental-health wards, led to unprecedented waiting times for psychiatric care.

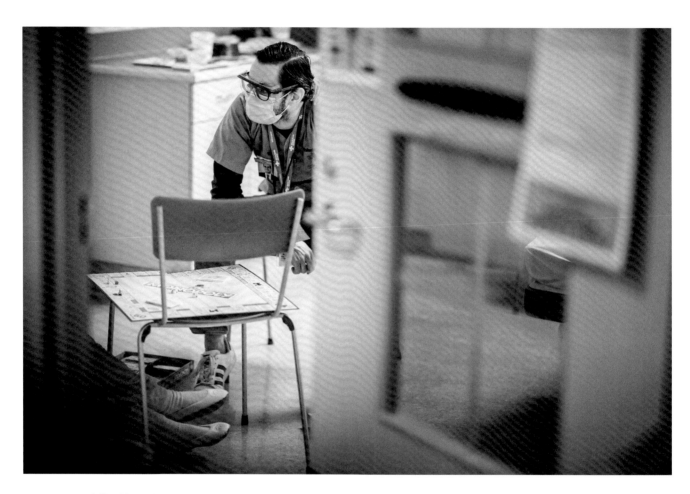

Mike Homuth, a volunteer at Alberta Children's Hospital, plays Monopoly with a teen admitted to the psychiatry unit after spending over fourteen hours waiting for a bed.

A girl who spent her sixteenth birthday on the adolescent psychiatry ward. With her hands tucked into the long sleeves of her black shirt and her feet encased in Lilo & Stitch slippers, she quietly showed me her room. Her two favourite stuffed animals sat on a pillowcase decorated with rosebuds and sleepy-eye designs. Her fuzzy grey blanket disguised the stiff, over-washed hospital blanket underneath. Teen novels were stacked on the floor, but the walls were strikingly bare. She told me she'd been in and out of hospital for most of the year, struggling with her mental health and missing many landmark events in a teen's life.

Multisystem Inflammatory Syndrome in Children (MIS-C)

Pediatric cases of COVID were usually mild, but by November 2021 Calgary had seen over sixty cases of MIS-C, a life-threatening inflammatory condition. Detected between four and six weeks after COVID infection, MIS-C often requires long hospital stays with monitoring and treatment in the pediatric intensive care unit (PICU) and ongoing medical surveillance for complications.

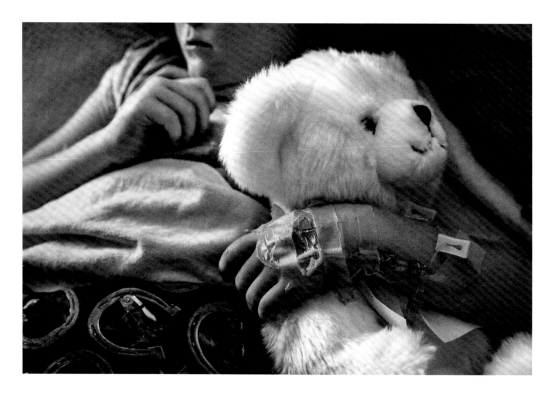

(above and opposite) Just released from PICU, Freddie, a six-year-old from rural Alberta, sleeps in her room at Alberta Children's Hospital while her mom cares for her six-week-old brother. Freddie was flown to Calgary and taken immediately to PICU for life-saving medical therapy. Her parents, Rebecca and Mike, spent over a week alternating between hours at her bedside and caring for her four siblings. Freddie's parents knew she was improving when her spunky personality started to shine through—a welcome change from watching her sleep the hours away under a quilt made by volunteers, clutching her new stuffed animal.

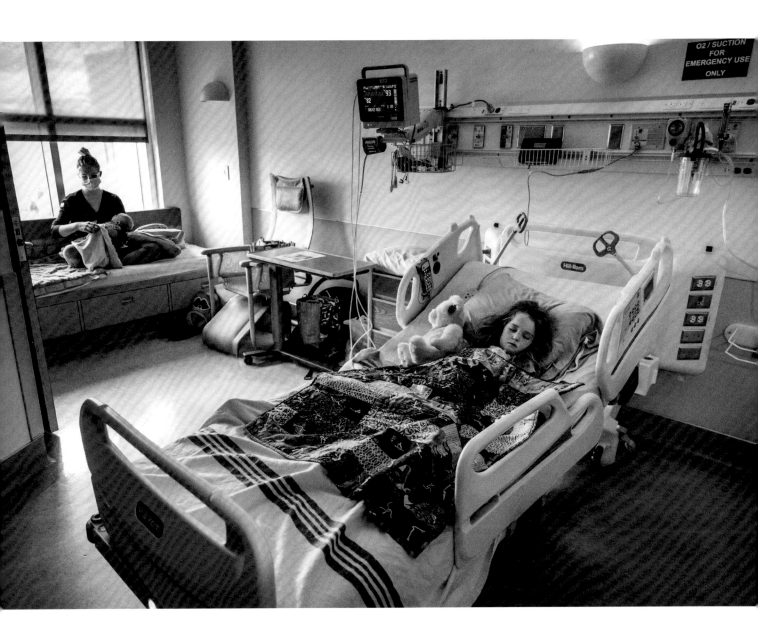

STARS and EMS

The rapidly shifting understanding of COVID required equally rapid changes in procedures for patient treatment and transport by STARS air ambulance and Emergency Medical Services. The integration of PPE, COVID testing in the community, and new protocols for treatments—in addition to interagency cooperation and communication—allowed these two distinct transport groups to keep delivering high-quality care.

(right) Members of the STARS Air Medical Crew return to the aircraft after delivering a COVID patient to the ICU. STARS crews are composed of physicians and specialized critical-care paramedics and nurses. They saw a twenty per cent increase in the number of transports during the fourth wave in Alberta and were involved in non-standard missions called load-levelling — bringing patients from rural to regional and urban ICUs. Dr. Jamin Mulvey, medical director of STARS Calgary Base, described how they successfully dealt with COVID procedures in the confined aircraft space: "Precautionary judgment, preparedness, procedures, decontamination, and knowledge of critical-care treatment has prevented transmission of COVID to crew members and pilots."

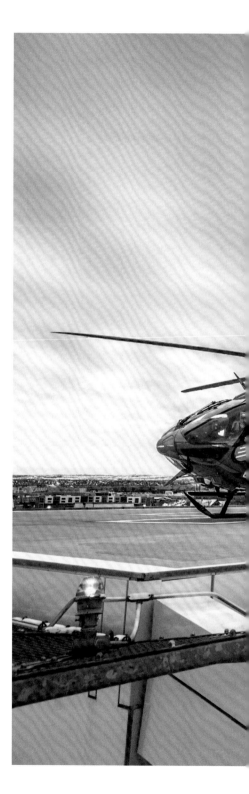

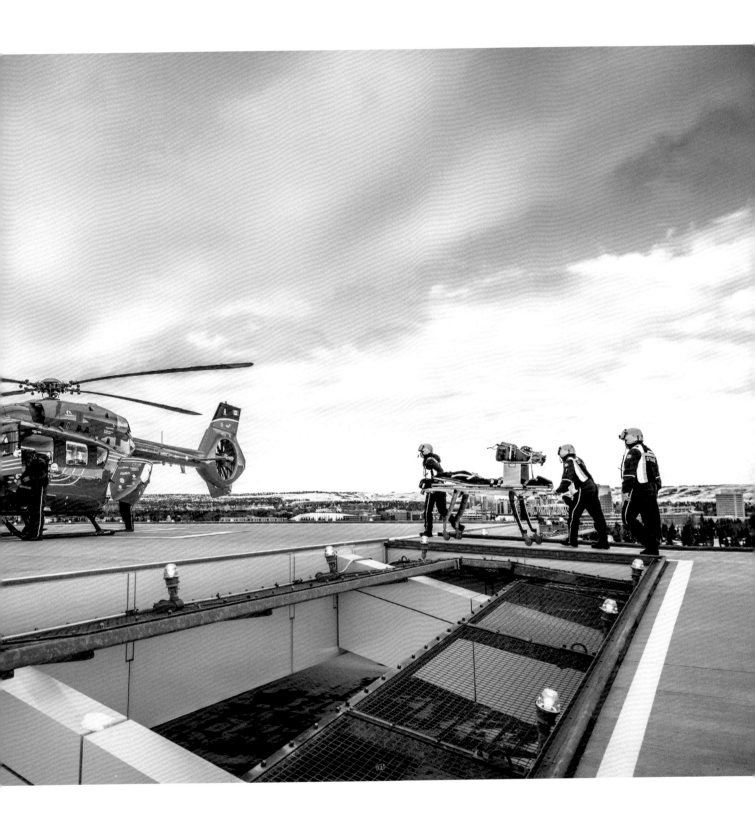

People Experiencing Homelessness

In 2018, the Calgary Homeless Foundation estimated that nearly three thousand people experienced homelessness on any given night. Because of frequent COVID outbreaks at emergency shelters, social organizations worked together during the pandemic to offer transitional housing, supportive housing programs, and a safe place to self-isolate. I referred many of my patients to the Assisted Self-Isolation Site (ASIS), a location for people who are experiencing homelessness or who are in need of a safe place to isolate after COVID exposure or infection. So I went there to better understand the incredible service ASIS provides. I met clients of all backgrounds, talents, and struggles.

(left) His third time at ASIS, a man sits in the shadow of his family crest, which he has etched into the window blind. He told me he has returned to making art as a way to manage the stressors and challenges he has faced during the pandemic. He described the feeling of long days of isolation and said he loves how sunlight passes through his etching, casting the image of his crest over him. ASIS is considered a success story and one that provides an example for an integrated social, medical, and housing response to those experiencing homelessness.

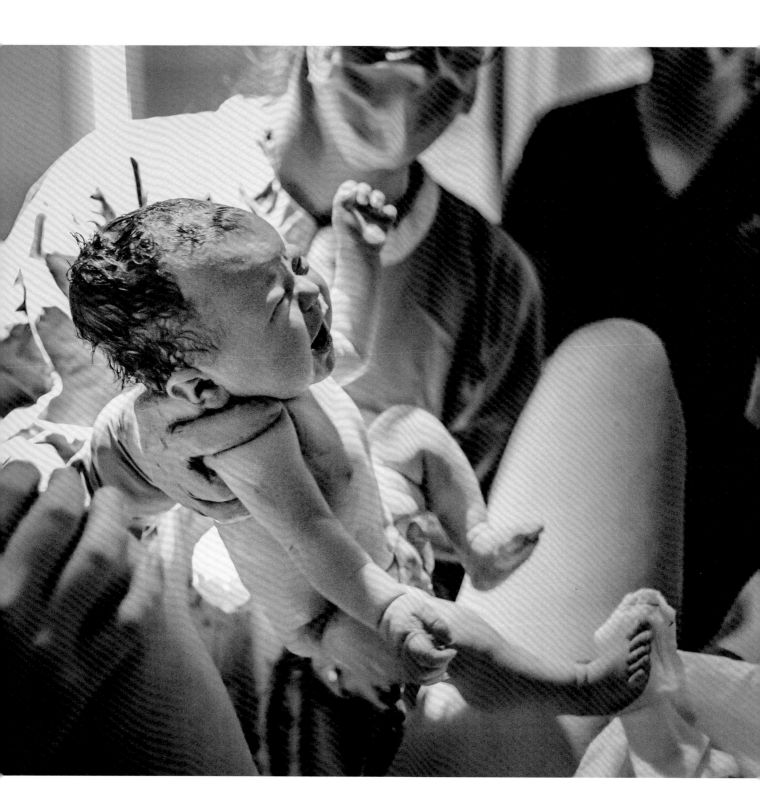

Obstetrics

Calgary's hospital-based labour and delivery teams deliver about eighteen thousand babies per year. During the pandemic, evolving knowledge about the transmission of COVID resulted in ongoing changes to protocols. Providing safe *and* compassionate care remained a priority. When my niece, Ada, was born during the pandemic, I got a glimpse from the patient perspective. Who would be able to be there for the birth? What if someone became unwell? Would we be allowed to visit? I wasn't able to be present for the birth of my niece, but as a physician-photographer I was privileged to photograph the exceptional work of the obstetrical and maternity care team.

(left) Lucy, first-born child of Kelsey and Adam, the very moment she arrives — almost one year into the pandemic. COVID impacted the entire pregnancy, starting with their first doctor's appointment and ultrasound. In the weeks leading up to delivery, they were extra-cautious about potential exposures at work, worried that a positive test for Adam would mean he'd have to miss the birth. Thankfully, it didn't happen. "We often reminisce about the absolutely stellar team of nurses, midwives, doctors, and students we had supporting us at Lucy's birth," said Kelsey. "Our nurse, Charlene, was phenomenal and made us feel cared for from the moment she first met us. She helped guide us, made us laugh, and helped us feel safe. She even visited us on the postpartum unit the following day, which felt special since we couldn't have any visitors come by due to restrictions."

Oncology

Special caution was also needed in oncology wards and clinics, since those receiving chemotherapy or immunotherapy are at an elevated risk of severe disease if they contract COVID. I remembered when my father-in-law, Gord, learned about his cancer diagnosis years earlier — how we navigated it as a family, together for his appointments, decisions, and treatments. And now, the pandemic meant that patients with cancer, more often than not, were without this kind of support. The nursing staff, aware of the impact of visiting restrictions, helped patients through the experience, encouraged them along the way, and celebrated their successes.

(right) For one patient, Janice, the end of immunotherapy is celebrated with the ringing of bells and a dance party, with the song "The Final Countdown" at full volume. After the final drop of medication filtered through her IV, bells were lined up in front of her — let the party begin! "Knowing I had to attend all my treatments alone meant I really had to up my mental game and have numerous tools in my toolbox," said Janice. "Key things like messages from friends, humorous videos, and music were important communication from outside the cancer centre. The approachability of the nurses made the experience bearable. Leading up to the last treatment, we avidly discussed which songs to play during and after my final treatment...I was very grateful that I never felt alone during this process."

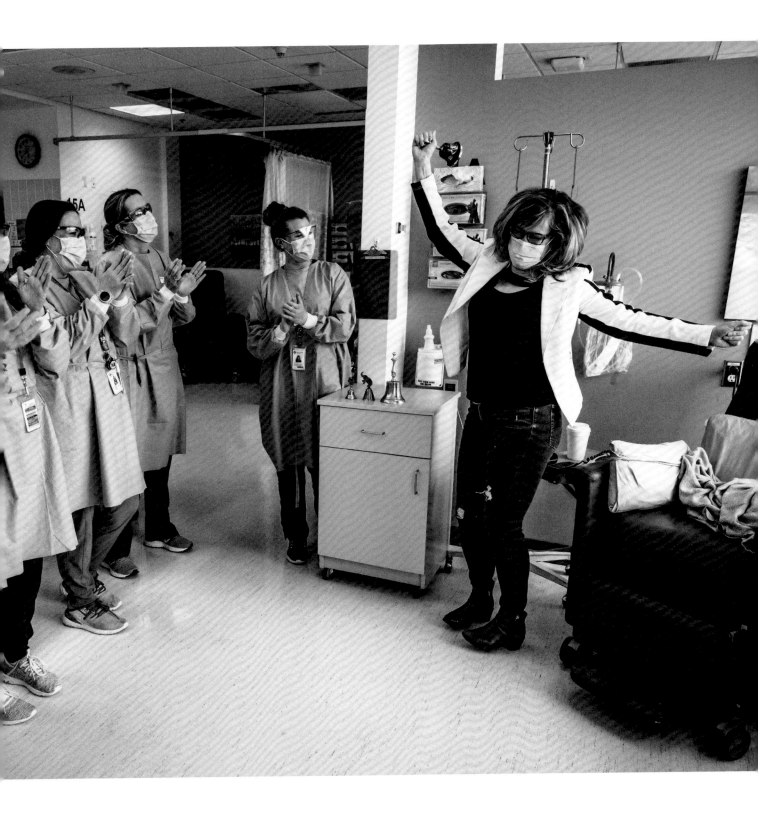

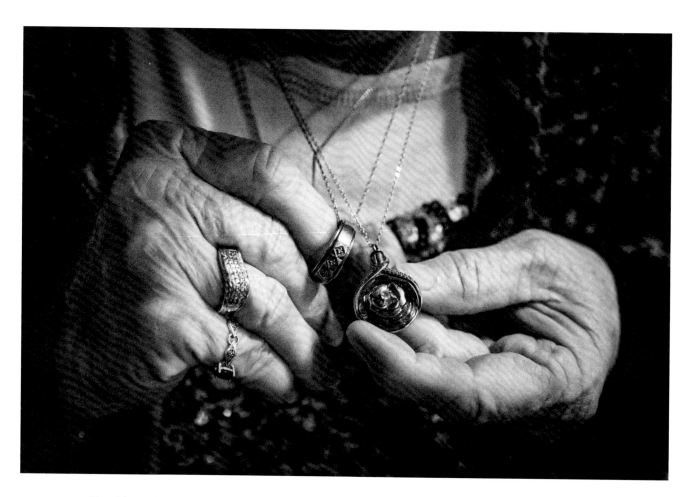

Chuck's wedding ring and a small vial of his ashes hang around Dixie's neck — a part of him always close to her heart. "The evenings are the hardest," Dixie said, as we sat in her living room full of memories of their rich life together. Chuck's empty chair, now upstairs, is surrounded by memorabilia: a screwdriver with a broken handle, often used and repeatedly borrowed; a painting of an eagle — his spirit animal — from his chief in Haida Gwaii, representing Chuck's strong connection to his culture; a colourful drawing by his great-granddaughter; a bottle of Grand Marnier, shared with friends around the campfire; and a sign that reads, "If Papa can't fix it, we're all screwed."

EIGHT
Pandemic Insight
Time to Create Change

"There are no more tears left, just the choice to move on, to appreciate life's moments, and make time for each other."
 —Andrew, a recovered patient

There is grief, and a lot of it. Now, in January 2022, we're in the fifth wave of COVID, and the numbers keep climbing. Globally to date, nearly five-and-a-half million people have died from COVID, including 3,338 Albertans. While there is no comparison to the loss felt by loved ones, I feel profound sadness when I learn that people I have met—either as my patients or whom I've photographed—have died. They will never be a statistic to me. I value the communication I've received from family members about how they celebrate the memories of their loved ones and my conversations with other health-care providers about how we honour the memories of those we have cared for.

I have learned that recovery from COVID is rarely over when patients leave the hospital. Some have overwhelming anxiety or guilt because they survived when so many others didn't. The trauma of isolation, intubation, and confrontation with mortality has left many with PTSD and critical-care-associated mental illness. Others suffer from long COVID—preventing a full return to their regular career and family lives. The broad range of long-COVID symptoms reflects the virus's effect on many different body systems and may include but aren't limited to shortness of breath, chest pain, headaches, distorted sense of smell and taste, brain fog, and severe fatigue. The long-COVID clinic in Calgary has a wait list that is several months long. For many, it will be a long road to recovery, one that needs to be acknowledged and supported.

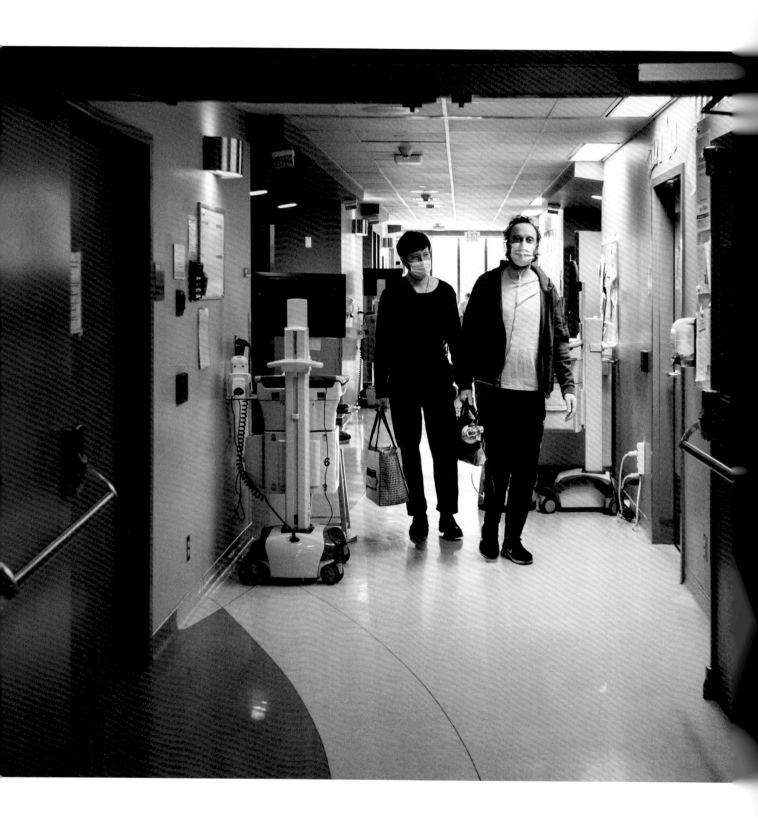

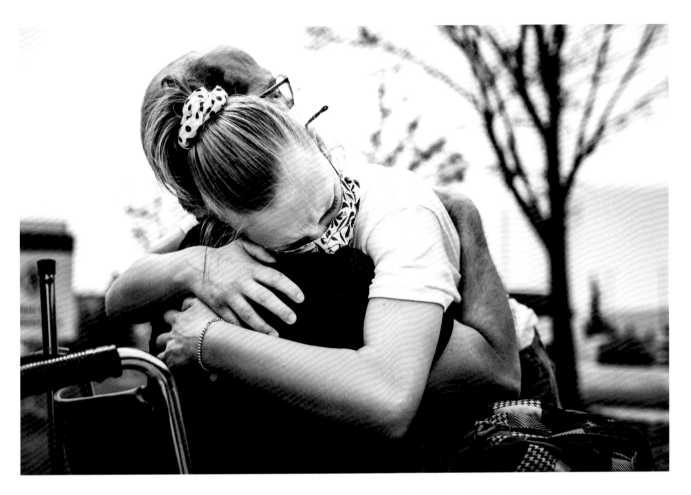

(above) Phil, going home. His family waited outside in matching T-shirts, holding signs. I stood with his mom, tears running down our faces, as each person embraced him. No one rushed — they leaned into their embrace, painfully aware of how close they had been to losing him. "Holding your baby girl again when you didn't think you would ever hold her again," said Phil. "It felt like everything was going to be okay in the world." However, Phil is now facing long COVID, unable to return to his usual fast-paced work environment or to his recreational activities with his usual intensity. He sees medical specialists regularly, but long COVID takes time — how much time, no one seems to know.

(opposite) Andrew and his partner, Eluvier, leave the hospital carrying his oxygen tank and belongings. They likened the experience to bringing a new baby home — winging it, and hoping it didn't explode. It would take weeks for Andrew's lungs to recover enough that he could go without the oxygen tank and many more before he could carry out his usual activities. He is now back to full-time work and no longer requires oxygen therapy.

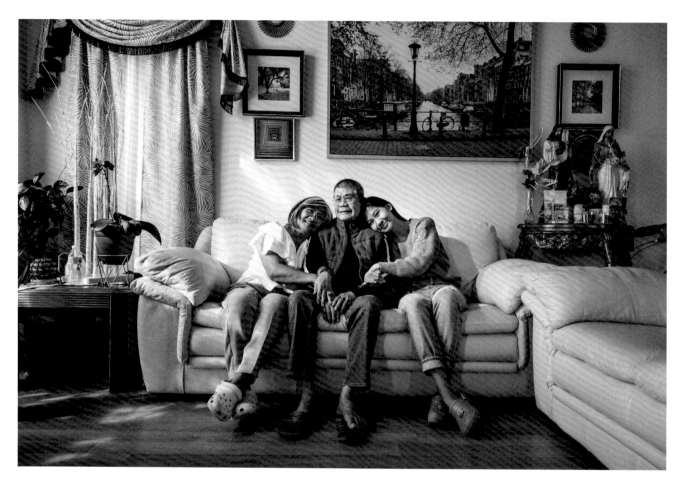

Asher, Elena, and daughter Resha at home. Asher described his experience with COVID as the most terrible of his life. He spent two months in ICU — four weeks intubated and another four weeks with a tracheostomy on a ventilator. Now, after four months on oxygen therapy at home, he is finally free from devices. As the family recalled Asher's time in hospital and the profound stress, sadness, and physical pain he experienced, the overwhelming sentiment was one of gratitude and appreciation for his care team. Doctors and nurses from ICU visited him on the COVID ward before he left for home, to celebrate his recovery. "I couldn't remember them because I was sleeping, but Elena does. It was amazing. They really cared." One day Asher plans to return to thank the people who saved his life.

Harvey happily shares an image of his first outdoor bike ride post-COVID. After thirty-eight COVID tests, every possible medical therapy, and nearly six months in hospital, Harvey returned home to his family. Even then, he remained on oxygen for months, trailing fifty feet of tubing connected to an oxygen concentrator that he kept in the front closet. He knew how to detect hypoxia (low oxygen) by how he felt if the tubing got kinked, disconnected, or stepped on. For exercise, he did laps from the front door to the back door while his dog, Jinx, happily bounced along. Harvey is back to riding his bike and continues to recover. Despite having received three vaccines, he doesn't consider himself protected and takes extreme caution to avoid exposure to COVID. Harvey and his wife, Cara, laughed when I asked what they were looking forward to. "It may sound funny, but we just want to be boring again."

The start of a new life for Sabbohi and Mohsin. "It wasn't the machines and tubes that saved my life," said Sabbohi. "It was the people." She has changed the trajectory of her career and plans to spend her life serving others "like those who cared for me," she says, in the hospital. She and her cousins in Pakistan are developing a project to empower young women in rural Pakistan by helping them gain vocational skills and providing support while they finish their education.

Rob and his wife, Misty, with their daughters Danica, Emily, and Rayna. Rob's recovery was swift. He returned to work shortly after being discharged. He has become a passionate advocate for vaccination, motivating others to protect themselves and their families. Stemming from this desire to help, Rob has also started a business focusing on education and awareness around personal finances.

+

While I have photographed some patients after they left hospital, I've spoken with many others to find out how they're doing and to again express my gratitude for how they welcomed me, briefly, into their lives. The post-transplant patient has been reunited with his family but is having a slower than expected recovery. Bernie continues to work on his physical and mental health, using traditional and holistic medical strategies—and is planning to write a book about his experiences with COVID and the health-care system. He has become a vocal vaccine advocate and shared his story on national media. Jim recovered at home and then, as he promised, started his new job.

The pandemic will leave few, if any, memories for the children I met. But their families will never forget. Nash fully recovered from his COVID infection and was approaching his first birthday the last time I spoke with his mom, Brooke. She described his infectious laugh, boundless energy, and love for his toy puppy that energetically eats pennies while wagging its bottom. Lucy, born during COVID, is now eight months old. "She is such a happy little gal and is chatting, singing, clapping, and laughing most of the time," said her mom, Kelsey. Freddie returned home with her parents and four siblings after nearly two weeks in hospital. She would *not* miss the hospital food, which she had found disgusting, and couldn't stop talking about tacos, her new favourite. Freddie finished her course of medications and made a full recovery. She was soon back to making comic books with her older sister and playing with friends.

And the stories of our hospital staff continue. Hospitals still have high numbers of emergency department visits for COVID and COVID-related mental illness, substance abuse, and addictions. Nor have we caught up with the backlog of surgeries delayed by the pandemic. Many health-care workers have left the profession, while others slog on, wading through the endless challenges. We are certainly not immune to the mental-health problems associated with the pandemic, and a number of people have told me, in confidence, about new or worsening struggles with anxiety or depression. Tragically, we have lost team members and co-workers

to suicide—sometimes never having realized the depth of their suffering. While each of us has experienced the pandemic differently, I believe that a change in the unspoken medical culture of silence is critical and that we need to create more dialogue about burnout, exhaustion, and mental health. Not only do we need to take care of ourselves—we also need to notice how others are doing around us and learn how to support one another.

(overleaf) Awaiting transport to the morgue. The room, once filled to the brim with people fighting for this patient's life, is now quiet, with curtains drawn.

Team members gather in small groups to debrief after their resuscitation efforts and mourn the devastating loss of yet another life and another family torn apart by COVID. The cumulative exposure to tragedy takes its toll. But many health-care workers remain wary of seeking help, worried about the long-term impact of mental-health stigma on their careers. Many, regardless of their role on the team, can relate to these words from an ICU nurse: "I am not going to leave nursing, but I certainly understand why people might."

+

At the time of this writing, the fifth wave of COVID, with the highly transmissible Omicron variant, has led to critical staffing shortages. Vaccination is effective in preventing severe disease in most people, but it doesn't prevent infection. Front-line staff, exposed to COVID and infected, are unable to work, leading to the closure of patient rooms and treatment spaces and to increased demands on remaining staff. And we are exhausted.

Perhaps, however, the pandemic offers us an opportunity to pause — to reflect and to decide if it will change the way we live our lives, both professionally and personally.

COVID has hurt me, deeply, but it has also coincided with this project, which has healed me. I took the opportunity to slow down, to take the time to look and truly see what is before me. I have had the rare chance to create space in which to process what I've experienced and to make meaningful connections with others from all walks of life. And I have allowed myself to feel again. I am reminded of the beauty, yet frailty, of life and the importance of community and connection. I have found *my* way to combat burnout and exhaustion.

I have rekindled my passion for being an emergency physician. And I now have a deeper appreciation of the interconnectedness of all staff and patients in the hospital and of the honour of belonging to this exceptional team. I will continue to express gratitude to *all* team members and find ways to flatten our hierarchical culture.

Patients and families I met while doing this project spoke with great conviction about the impact of health-care workers' kindness. After hearing their words, I now spend even more time with my patients and their families, at the bedside or on the phone, making sure they understand what is happening and feel supported. While providing episodic care is a reality as an emergency physician, I have learned to avoid the emotional disconnect of being left with unfinished stories. I now follow up on my patients more thoroughly by reading their discharge or clinic notes and sometimes by visiting the ward where they've been admitted. I am

grateful that hospital rules allow this for as long as I am still within their "circle of care." On difficult shifts in the emergency department—which are inevitable—I understand more about myself as a physician and can draw on my reflections and experiences during this project and the pandemic. This takes me back to the place I needed to get to, where I know I am once again able to give my all to my patients.

My family life, though fraught with the same challenges others have faced in the past two years—online school, loss of extracurricular activities, disrupted social connections, and isolation from extended family—has also experienced growth. We will not forget the difficulties of the pandemic, but we will remember the joy of being together and the importance of being intentional with how we spend our time.

However, I still have much to learn. Due to my lingering struggles with imposter syndrome, my tendency is still to keep pushing for perfection—to set a goal, achieve it, and immediately move on to the next. I love tackling the challenges that I've set for myself in all categories of life, but I remind myself that I don't *need* to do that in order to validate my worth or prove my proficiency. The care I provide to my patients is evidence-based and compassionate, and my contributions to the medical community are important. My story is worthy of sharing even though it reveals my imperfections; my family life is full of love despite the chaos and the mistakes we make. It is okay to just be me, to make the best choices that I can, and to live according to my personal values.

It has been hard to step out, to share my experiences and private life with friends, colleagues, family, and readers. But following the example of the people I have met and photographed, I have chosen authenticity over comfort. I hope that these photographs and stories will inspire others to do the same.

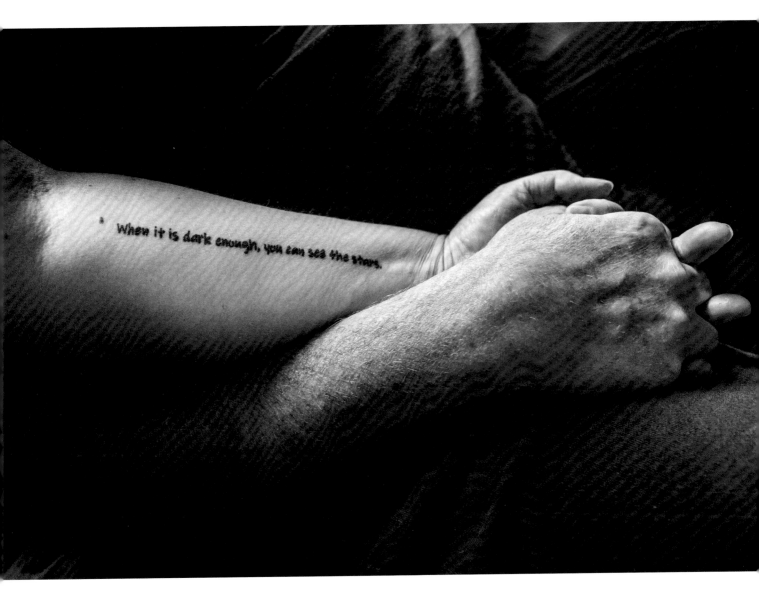

A tattoo on the forearm of a recovered patient's wife. I have been inspired by the people I have met and challenged to remain hopeful in my personal and professional life.

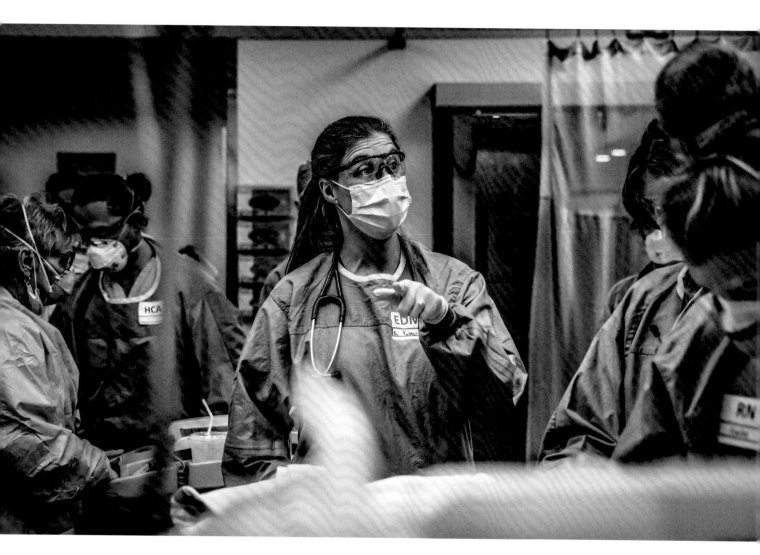

The author at work in Trauma Bay 1. (Photo: Leah Hennel, AHS)

Acknowledgements

To the patients and families that I met during the pandemic, thank you for sharing your stories and helping us understand the personal impact of COVID. Your strength, faith, authenticity, and resilience during some of life's most challenging moments have inspired me and helped me grow personally and as a physician. Although not everyone I photographed appears in this book, each one has had an impact.

To the staff at the community organizations, vaccination clinics, and the five hospitals where I photographed—Foothills Medical Centre, Rockyview General Hospital, Peter Lougheed Centre, South Health Campus, and Alberta Children's Hospital—thank you for trusting me with your emotions and your stories, and for welcoming me into your daily lives. I know it wasn't easy to have a stranger with a camera show up at your workplace, sometimes on the most difficult or busiest days. These images remind me that we are all in this together.

To the emergency department staff, who are my friends and colleagues, a special thank you. I started this project with your encouragement and willingness to let me be your paparazzi. Thank you for never giving up despite the challenges we face. I have thousands of photos that will forever make me smile, because I see the care, camaraderie, and humour that makes me love being part of our team.

To the Alberta Health Services (AHS) leadership and communications teams, thank you for taking the bold step of letting me photograph inside the hospital—something that had never been proposed in Calgary before. To Blain Fairbairn, a special thanks for working through the details of this project and for advocating and supporting me throughout. To Michael Suddes, thank you for your enthusiasm and support for this project. Your enduring commitment to staff and patients, your kindness, and your leadership style is inspiring. When you arrive in the emergency department at five p.m. "to move stretchers," I always wish I could make a photograph of this exceptional human who likes to help out but *doesn't* like his photo taken!

To Susanne Alexander, Matthew Halliday, Alan Sheppard, Julie Scriver, Jeff Arbeau, Ben Burnett, and the team at Goose Lane Editions, thank you for taking a risk by publishing a book by this non-photographer photographer and non-writer writer. It has been an honour to work with you and learn about the publishing world. Thank you to my wonderful editors, Valerie Mansour and Sue MacLeod. Val, thank you for embracing my vision and working alongside me from the start, for pushing me to keep going when I thought I was done, and reminding me that I can always say the same thing with way fewer words! Sue, thank you for your belief in the value of this project, your attention to detail, and your commitment to ensuring that not only does the book follow the rules of grammar (except for the one sentence that I really wanted to keep!) but does so with elegance.

To Deb Schwedhelm, thank you for guiding and directing me, for challenging me to expand my skills in journalling and in photographing even when I thought I had no ideas left. To Dana Pugh, thank you for teaching me my first storytelling photography course, for your help critiquing photos, and for creating emergency-staff portraits. To work alongside you was a highlight, making me feel like I had "made it."

To my closest friends on this crazy journey to becoming older and wiser, thank you for loving the real me, for teaching me to dance and take myself less seriously, for being there during life's most important moments, tolerating my slow replies to emails and texts, and for finding my wallet when I have lost it…again. I love our adventures together and I'm so thankful for you.

To Margaret, thank you for pushing me to tell even the toughest parts of the story, and giving me feedback along the way. To my friends and colleagues who read my proposals and drafts and offered suggestions and points of clarification, thank you for your insights and your help, sharing what our medical world is like.

Mom and Dad, you taught me to be courageous, that I could do anything I put my mind to. You lead by example, pursuing your dreams, following your hearts, and never being afraid to start a new adventure. I think you believed I could do this even before I could. To Ashleigh, my voice of reason, and Kenny, thank you for reminding me that although vulnerability and authenticity are not easy, they are worth pursuing wholeheartedly. Your encouragement to stretch myself and grow helped me get to where I am today. To the Rodgers side of my family, thank you for helping me learn how to slow down and enjoy the beauty of living in the moment, a skill that I needed in order to find moments of light within the pandemic.

Together in the mountains. (Photo: Hannah Rodgers)

To Quinn and Hannah, thank you for not smiling for the camera but instead giving me the chance to capture real life—the spunky, messy moments that we look back at and laugh about. Spending time with you was the silver lining of the pandemic for me.

To my husband, Kip. I love our crazy life—the adventures amidst the chaos, the laughter despite our difficulties, and the shared understanding of being emergency physicians. Thank you for making this book happen, carrying the weight of our family life, and looking at every image I created—all 47k! Without you we would have a house full of open cupboard doors, I wouldn't ever find my phone or car keys or the shirt I need, and I certainly wouldn't have half as much fun. Someday, I promise, I will get my act together. I'll start, just after I finish this next project...

Heather Patterson is an emergency physician and photographer from Calgary. When the pandemic struck, Patterson decided to put her twenty years of photography experience to use and began capturing the intimate moments at Calgary hospitals that went on to become *Shadows and Light*. Images from the project have been featured in *Maclean's*, where they were a finalist for a National Magazine Award, and the *Calgary Herald* and on CBC, CityNews, Global News, and CTV. Patterson has received the Award for Medical Journalism from the Canadian Association of Emergency Physicians, and her work has been featured in medical journals and presented at conferences and grand rounds across the country.